TREVOR WAUGH'S

Winning with WATERCOLOUR

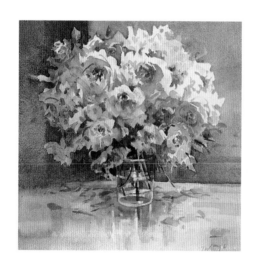

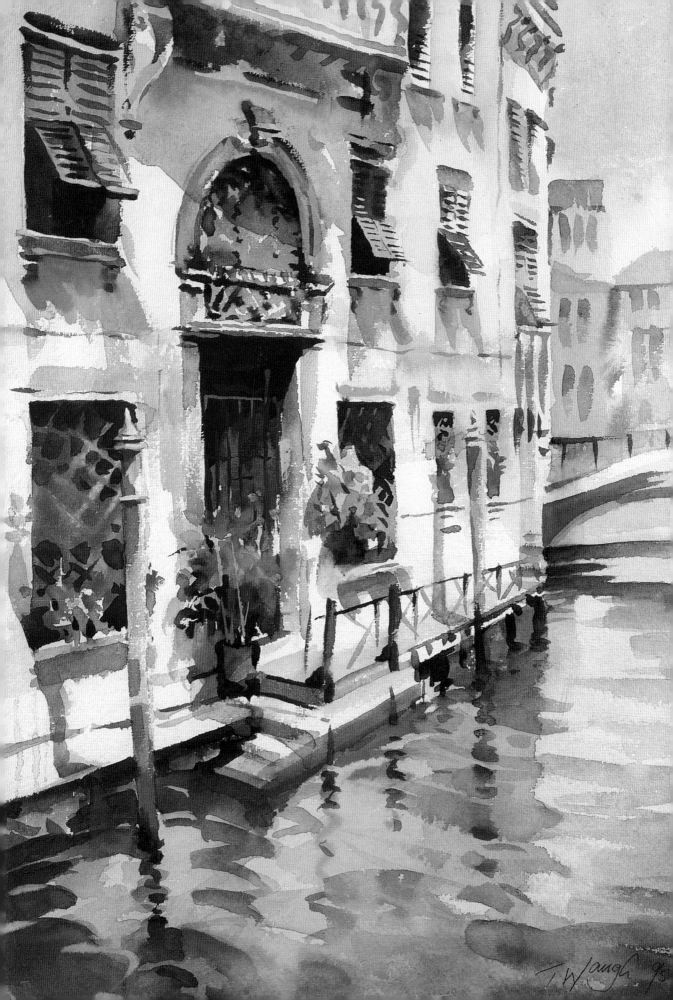

TREVOR WAUGH'S

Winning with WATERCOLOUR

Tips and techniques for atmospheric paintings

Collins

First published in 2000 by
Collins, an imprint of
HarperCollins*Publishers*
77–85 Fulham Palace Road
Hammersmith, London W6 8JB

This edition first published in paperback in 2006

The Collins website address is:
www.collins.co.uk

Collins is a registered trademark of
HarperCollins Publishers Limited.

10 09 08 07 06
8 7 6 5 4 3 2 1

**A catalogue record for this book is
available from the British Library.**

EDITOR: Diana Vowles
DESIGNER: Penny Dawes
PHOTOGRAPHER: Howard Gimber

ISBN-13 978 0 00 721690 1
ISBN-10 0 00 721690 4

Colour reproduction by Colourscan, Singapore
Printed and bound by Printing Express Ltd,
Hong Kong

PAGE 1: *Roses for Tom* 30.5 x 30.5 cm (12 x 12 in)
PAGE 2: *Venetian Palace Doorway* 45.75 x 35.5 cm (18 x 14 in)

DEDICATION

I dedicate this book to my mother Nancy (1926–89), whose constant encouragement taught me what winning really means.

ACKNOWLEDGEMENTS

I would like to thank Caroline Churton and Cathy Gosling at HarperCollins for all their enthusiasm and practical help, and John Gilboy and Brenda Howley for suggesting I write a book in the first place. Special thanks to my dear friends Tom Phipps, Alain Rouveure, Toni and Ian Cresswell, Adam Sawell and of course Norma Keates who have not only been good friends but also tireless supporters, understanding when I am unavailable because I have gone away painting again.

I would also like to thank all my students for teaching me as much as I teach them; my daughter Rhianna, who is a constant joy and inspiration to me; my goddaughter Bryher Cresswell, a blessing; Mark and Jan Roach for keeping my facts and figures in order; the Majlis Gallery in Dubai for supporting me to paint in the Middle East; Mohammed Al Murr for his friendship and inspiration; Bill Bartrop, my friend and confidant; Tony and Yona Wiseman for making a difference to me and others; and all my teachers from the past who invested their time and effort in me – I hope they feel that the baton they passed on to me was well placed.

Lastly, I would like to thank my wife Michèle, who is not only my soulmate but also a constant companion bringing both love and support to me in abundance, and who has been an enormous help in writing this book.

Contents

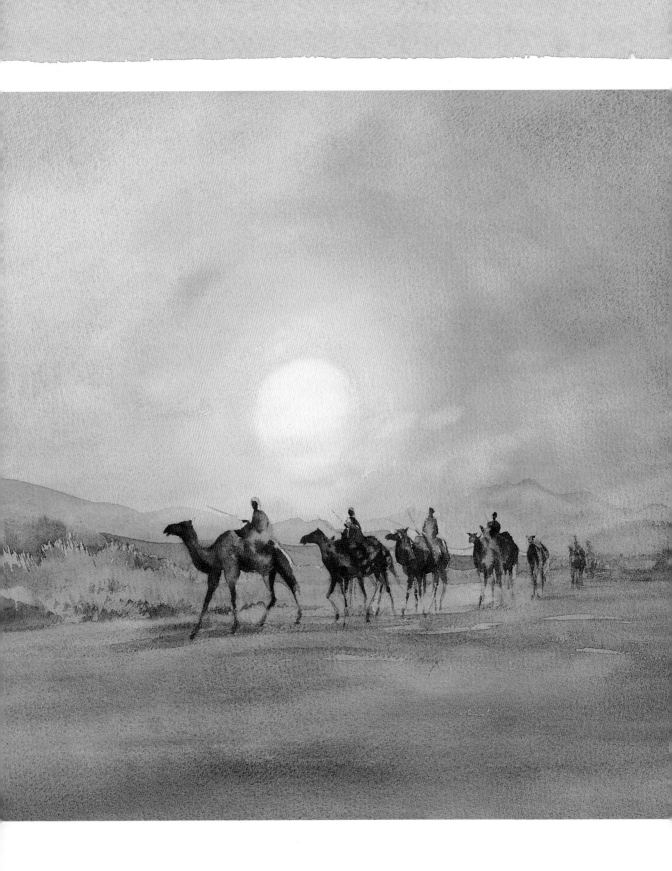

Introduction

There are many ways of painting in watercolour, although it is a commonly held misconception that there is just one right way to use the medium. After years of painting and teaching in watercolour I have developed a way of working that I find not only inspirational but also helpful to students at all levels of experience. In this book I have outlined the five main methods and skills that I look for in a watercolour – large washes, wet-into-wet, soft darks/hard lights, bold brushwork and achieving transparency – and explained in detail the various ways of using them. This is very much a personal approach and I stress that it is just one way to work, not the only way.

Small steps

There is a lot to learn when you first begin painting in watercolour, but if you start off with small steps your confidence will grow. You may find that what started as a leisure interest becomes an all-consuming passion. I have found that painting in watercolour is not only a challenge but enormous fun; with just a few materials you can make something appear on a blank sheet of paper that was not there before. This small act of creation is a constant thrill.

◀ **Sunset Riders**
34.5 x 49.5 cm (13½ x 19½ in)

To capture this desert sunset I used a basic four-colour scheme of Cadmium Orange, Aureolin, Rose Madder Genuine and French Ultramarine. I worked around the setting sun with a damp brush to keep it soft-edged and added a few accents to the silhouettes of the riders with Coeruleum and Burnt Sienna.

An expressive approach

I constantly try out new subjects or ways of handling light and colour. I also study other artists' work and have great respect for watercolourists such as Turner, John Singer Sargent and Whistler who were innovative and expressive with this most challenging medium. When I paint I like to do so in a direct way, straight onto the paper with no pencil outlines to inhibit me. I have found this method helpful in reducing tight details in my work and establishing much more of an impression of the subjects that I see. Painting is a metaphor; it is like what you see, but it is not what you see. This is not to say that

drawing with a pencil is not important – it is an excellent discipline and can really hone your ability to create a three-dimensional sense of space on a two-dimensional surface. It is just that I now choose to save my pencil for sketching in my sketchbooks and journals.

Finding inspiration

There is a myth that if you are born with talent painting is plain sailing all the way. In fact, it is difficult for even the most experienced painters to express themselves in the way they want. This is worth emphasizing because so many students

◀ **Tranquillity**
45.5 x 35.5 cm (18 x 14 in)

In this floral painting Rose Madder Genuine and Crimson Alizarin were used to create the pinks and Coeruleum and Aureolin were combined to make the apple greens. This vibrant colour relationship is offset by the use of more neutral tones around them.

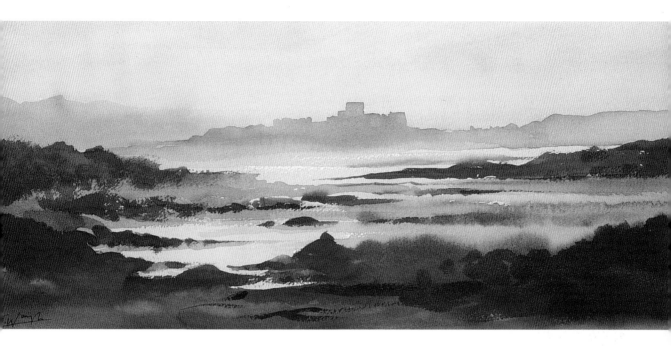

become disheartened after the initial surge of enthusiasm and feel that they do not have enough talent to become more accomplished. This is not true: to improve your painting all you need is a sense of adventure, a little commitment and a great deal of patience.

These days it is popular to talk of learning curves and we are encouraged to see ourselves gradually

▲ **The Isles of Mogador**
23 x 49.5 cm (9 x 19½ in)

While I was staying in Essaouira in Morocco I was able to watch magnificent sunsets over the Isles of Mogador from the roof of the hotel. I particularly enjoyed the extreme contrast between the light of the setting sun and the dark foreground.

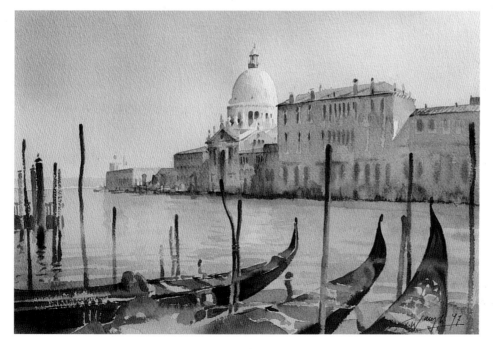

◀ **The Grand Canal, Venice**
24 x 33 cm (9½ x 13 in)

The church of the Della Salute in Venice is one of my favourite buildings to paint. I started with an initial variegated wash, then painted the buildings and lastly the gondolas and posts. The very dark areas in the foreground were painted with a mix of French Ultramarine and Burnt Sienna. French Ultramarine and Naples Yellow were used extensively in the sky and the buildings.

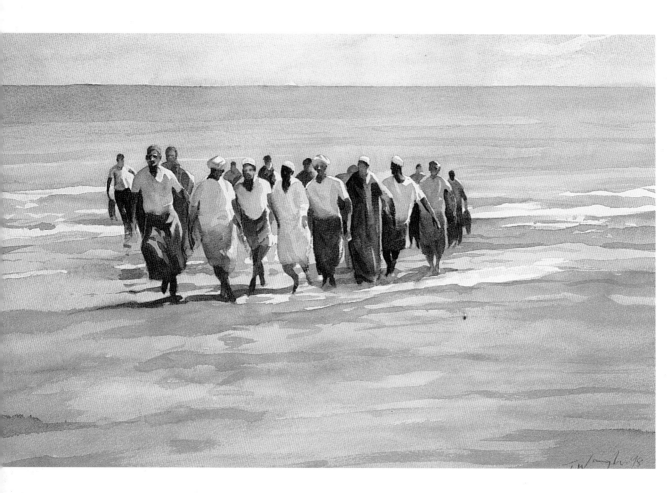

▲ Fishermen on Khorfa Khan Beach
32.5 x 49.5 cm (12 3/4 x 19 1/2 in)

The light and colour were what inspired me to paint this scene in the Middle East. The way the figures group together, some partially hidden behind the others, was an opportunity to use negative shapes. The light areas were left from my initial pale multicoloured wash, which included Naples Yellow, Raw Sienna, Cadmium Orange, Coeruleum and French Ultramarine.

moving towards our goal, whatever it may be. I have found, however, that I learn in lumps; my painting seems to be going along well, positively flowing forth, and then all of a sudden it comes to a grinding halt and it seems an uphill struggle to get going again. This is perfectly normal, and if you ever feel this way do not give up painting; I believe that the only failed painter is one who stops painting. At times like this I find it helps to remind myself why I started painting in the first place. I visit all my favourite galleries in London, frequented since my student days, and I think very hard about what it is I am trying to say in my work. Invariably I return to the artist's anthem: light and colour.

No artist paints reality the way it is, but only an interpretation of it, a reflection. When the artist is inspired this reflection comes from the soul. Each of us has the ability to touch this in ourselves. So, when I see the sunlight spreading its colours along tree-lined horizons, when I feel the soft winds of heaven touch me, when the whole world seem palpable with beauty before me, I am moved once again to dedicate myself to art, the echo of the beautiful.

This book gives practical instruction on how to achieve results with watercolour, covering a variety of different subjects and techniques. My intention is that you will then be able to incorporate these techniques in your own work. Reading the book from cover to cover may not be as valuable to you as dipping into it as a resource for both information and, I hope, inspiration.

▶ Evening in the Roman Forum

33 x 49 cm (13 x 19¼ in)

The Forum in Rome is strikingly beautiful, especially at sunset. I set out to paint the grandeur of the architecture and capture the atmosphere through the use of warm and cool colours.

▼ Plymouth Reflections

32.5 x 49 cm (12¾ x 19¼ in)

In this painting my main aim was to capture the light on the water. The whole scene is backlit, creating interesting silhouettes, shadows and reflections. I kept my palette fairly limited, using primarily blues, greens and greys.

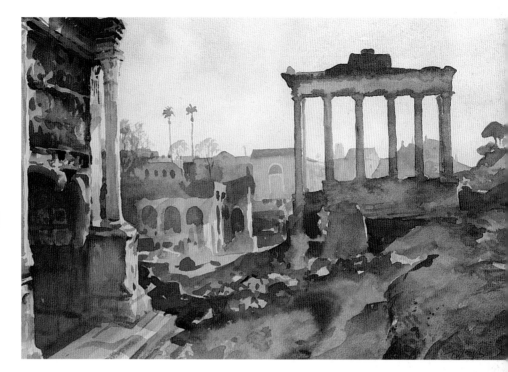

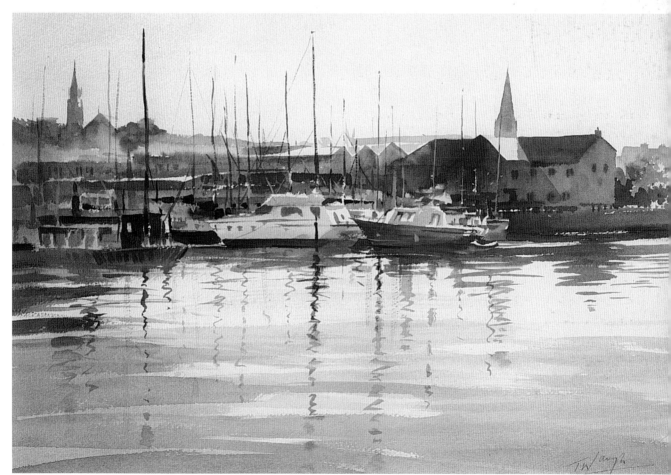

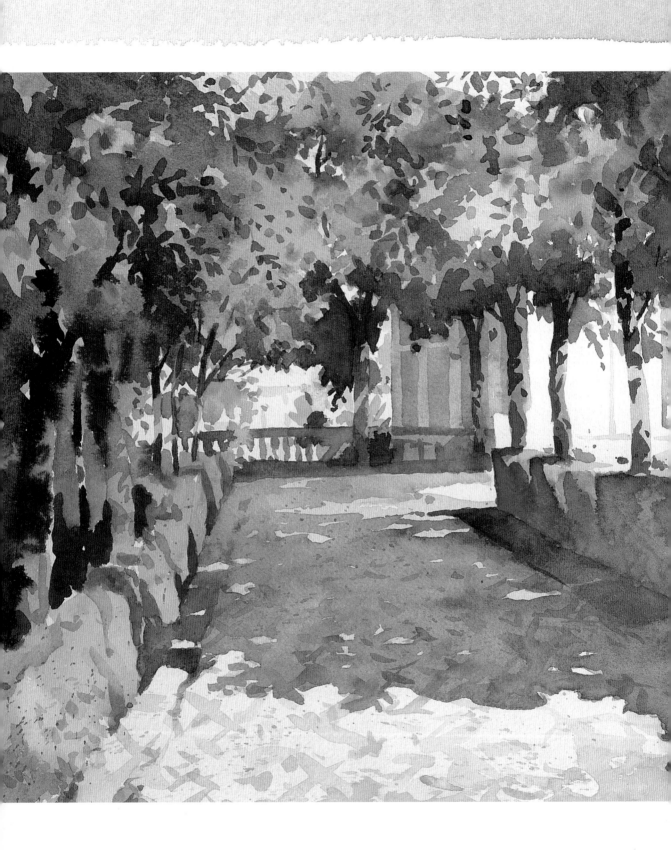

Materials and Equipment

It is wonderful to have a vast array of materials and equipment available in the shops, but in fact little is needed to paint a winning watercolour; sometimes just three or four colours, a brush, water and paper. Generally speaking, my materials divide into two groups: a field painting kit, which is very basic and lightweight, suitable for travelling or painting *en plein air* (on location); and a studio set-up, designed to meet almost any technical requirement. It is worth getting good-quality materials made by a reputable manufacturer and if you're serious about painting you should buy the best your budget allows.

Experimenting with materials

Most of the materials mentioned in this book can be obtained from your local art shop or from mail order suppliers. However, as you begin to develop your skills you will find yourself experimenting with more unusual items, such as pieces of wood or string to scratch or roll over the paper in order to produce exciting textures, or using wax, soap or salt to act as a resist. The list of extra materials is seemingly endless, but for now concentrate on developing your skills with the more traditional materials and equipment that are listed here.

◀ **The Farnese Pavilions**
33 x 49.5 cm (13 x 19½ in)

Sitting on top of the Palatine Hill in Rome, I sketched the Farnese Pavilions with watercolour in my journal. The faint breeze of early morning caused the leaves to cast dancing shadows on the path. When I was back home in my studio I painted the finished piece, using my journal as reference.

Watercolours

There are many brands of paint on the market, but watercolours are compatible across the board and one brand should happily mix with another. While I mostly use Daler-Rowney Artist's Quality watercolours, I do prefer some individual colours in other ranges.

Artist's-quality paints are more expensive than the student ranges because they contain more pure pigment and fewer fillers, additives or extenders. If your budget can more comfortably run to the student ranges you can try out paints from a basic 12-colour box and concentrate on developing your skills. Stunning watercolours can be achieved with only a modest kit and a lively imagination. However, good-quality paints can go a long way with just a drop of water, so cheaper ones can be a false economy as well as giving you poorer results.

Watercolours are available in pans, half-pans and tubes. An enamel box containing 12 pans of colour and with a lid that can be used as a palette is extremely useful, as your paintbox can not only be a container for your paints but also a portable mixing desk. If you want to cover larger areas of paper, though, tubes of soft colour are preferable. There is nothing like getting the colours flowing together over a large sheet of watercolour paper to test your imagination and skill with this exciting medium.

In the studio I use tubes of pigment. They can also be used to refill empty pans – simply squeeze the paint in and allow it to dry. It is a good idea to buy the larger 14 ml (½ fl oz) tubes of the colours you use most. If the pigments dry out the tubes can be broken open and the paint used exactly like a pan colour so that they are not wasted.

A good starting point for beginners is a 12-colour kit of tubes consisting of the following colours:

Cadmium Red	Cadmium Yellow
Crimson Alizarin	Yellow Ochre
French Ultramarine	Raw Sienna
Cobalt Blue	Burnt Sienna
Coeruleum	Burnt Umber
Prussian Blue	Viridian

With time you will work out a palette suited to your style containing some basic colours that you will find you cannot do without.

▶ In the journal shown here I have painted a few of the materials lying around in my studio. On the work-table you can also see a nine-hole palette together with a variety of brushes and tubes of paint.

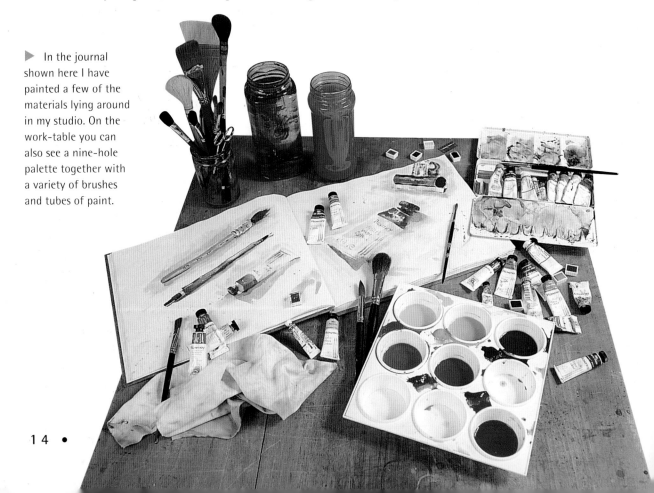

Paper

There are a wide variety of papers to choose from,
but always make sure that you use watercolour
paper as it is especially designed for the purpose
of holding the liquid and colour through its
absorbency, and when dry should flatten back to its
original state. It is important to choose a paper you
feel comfortable with. Hand-made papers are the
best and most expensive, and for cheaper alternatives
there are mould-made and machine-made papers
too. However the paper is made, look for a high
degree of rag content as this makes it long-lasting
and durable in working.

There are numerous surface textures to papers.
While they vary greatly from brand to brand, they
basically break down into three categories: Hot
Pressed (HP), a smooth surface, Cold Pressed (Not),
a medium surface, and Rough, which has a larger
tooth to its surface. The tooth or surface texture
contributes a great deal to the look of the washes
and I prefer Not or Rough, which add more texture
to the brushwork.

▲ Here are a few of the various papers that I use, including
my favourite journal, a leather-bound book I bought in
Venice. You can also see a few pencils, a tortillon and a
putty eraser.

There are different weights or thicknesses of
paper, ranging from 150 gsm (72 lb) up to and
sometimes over 850 gsm (400 lb). Any paper less
than 300 gsm (140 lb) will probably require
stretching on a board to prevent it from buckling
when wet.

To stretch paper, wet both sides of the paper
either under the tap or with a sponge, then use
gummed paper to adhere it to your board. If you
stretch paper it removes the surface resin, making it
more absorbent; if you don't stretch it, the paper
slightly resists the wash. I like that effect and the
sense of control it gives, so I tend not to stretch my
paper before I paint.

I generally use Whatman watercolour paper, either
300 gsm (140 lb) or 400 gsm (200 lb), taped to a
ply board using 5 cm (2 in) paper masking tape.
Whatman paper is very white and shows up colour

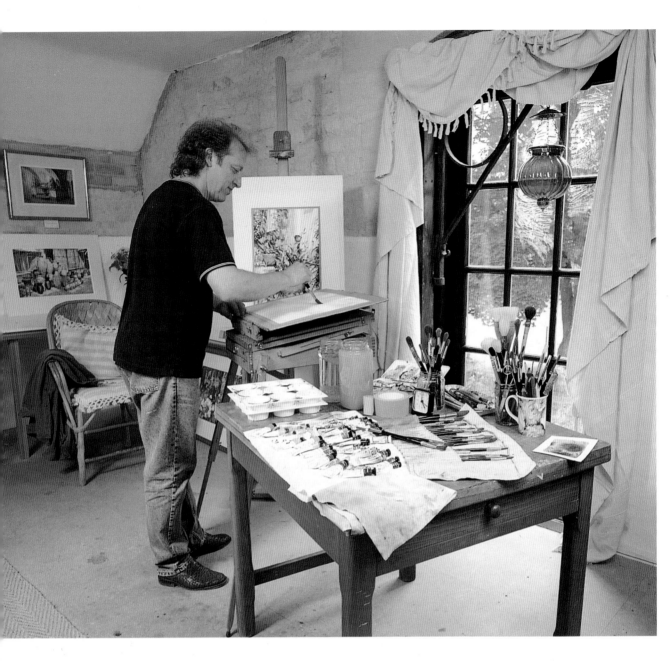

▲ Trevor working at his freestanding easel at the end of his studio at Great Barrington in Gloucestershire.

really well. I sometimes use Indian Village 100 per cent cotton rag hand-made paper; this is moderately priced, but it is not as white and has a tendency to buckle at the edges when dry. I also use sketchbooks or journals of hand-made paper for gathering reference and inspiration.

A good paper for beginners is Saunders Waterford, because it is a good all-round paper and works well stretched or unstretched. It is also more forgiving than other papers. For weight and surface, I suggest 300 gsm (140 lb) Not.

Brushes

A large selection of brushes is very useful but, like me, you can build up a collection over a period of years. Round brushes in a variety of sizes, for example No. 14, No. 8 and No. 5, are a good place to start. Sable brushes are to be preferred, such as Daler-Rowney's Diana and Kolinsky ranges, and

although they are expensive they do last longer. Brushes made of a synthetic/sable mix are a reasonably priced alternative. Mops or soft-hair brushes are good for laying in large washes, and a flat brush that has a square end has a multitude of uses, such as for painting brickwork.

When choosing a round brush, make sure it comes to a tip when dipped in water and springs back to its original shape after it has been used; most good art supply shops will allow you to try brushes before purchase, and a glass of water is often provided at the brush counter for this very purpose. I reserve old brushes that have lost their tip for mixing, as this reduces wear and tear on my new brushes.

Miscellaneous items

Apart from the basic requirements for traditional painting in watercolour, there are a few miscellaneous items you may find handy. A folding desktop easel is useful for supporting your board, although a brick or other item will suffice. A fold-up freestanding box easel is more expensive but useful if, like me, you enjoy painting standing up, and it can house all your materials if packed correctly.

Smaller items include a good craft knife or blade with which to scratch out paint as well as to sharpen pencils; elastic bands, which are invaluable for all kinds of things, especially holding open the pages of a watercolour sketchbook to reduce the buckling effect on them, and which at a pinch can even be used as an eraser for unwanted pencil marks; an HB pencil for drawing in difficult areas; large jars for water and a small watertight plastic container for use outside. Last of all, you need plenty of palettes; you can never have enough mixing areas. Over the years I have used Daler-Rowney educational stacking palettes for mixing, with either six holes or nine holes. They look just like muffin tins, and I have found them to be excellent allies.

▶ Here, seated on a bridge over the River Windrush in the Cotswolds and accompanied by his faithful companion Bumble, Trevor is painting a landscape in his journal.

Field kit

For painting outdoors a pan or half-pan set is most convenient because you can pack up and move on without much fuss; I use a Daler-Rowney metal-box half-pan set with 12 colours.

You will need a painting journal, which is to say a bound book of watercolour paper, or a spiral-bound pad of about 300 gsm (140 lb) weight. One of the benefits of a journal is that because it is hard-backed there is no need to carry a board around with you. I usually take a large, medium and small brush with me. You will also require a watertight plastic container. I use a 500 ml (1 pint) square milk carton with a wide screw top for easy brush access, which is lightweight and refillable at any water stop; you can also use the top for mixing. Two wide elastic bands will come in useful for a multitude of things, and an HB pencil will suffice for drawing. It is not essential, but I like to take an additional palette with me, such as a Daler-Rowney BB6, so that I have extra mixing space. You can strap it to the back of your journal using the elastic bands. A plastic carrier bag is convenient for putting your dirty palette in afterwards.

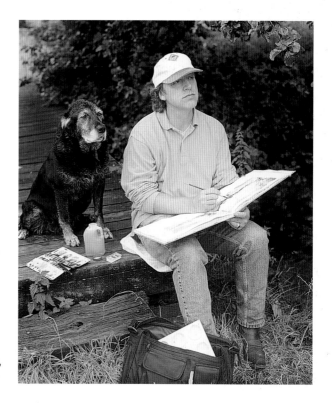

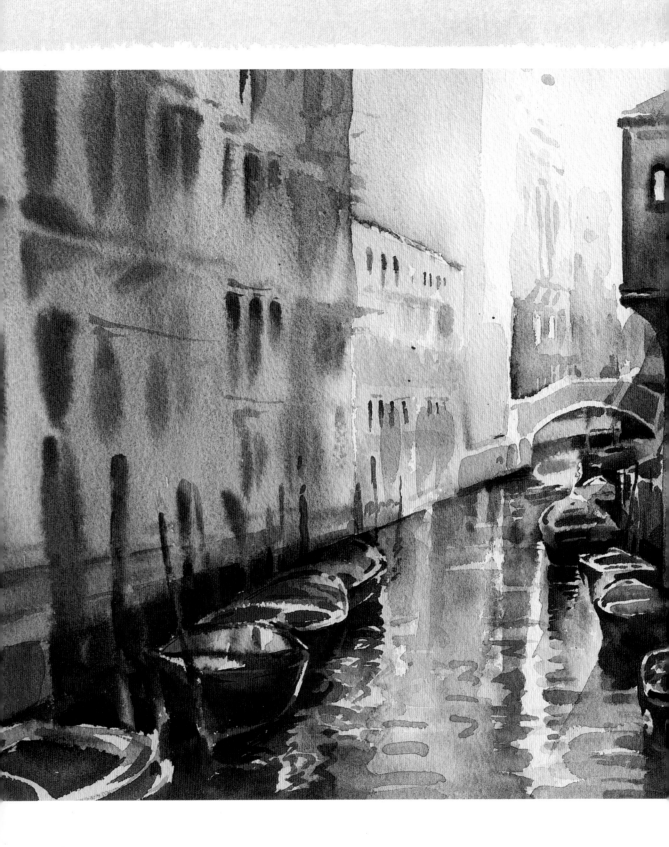

Watercolour Methods and Skills

Your early attempts at watercolour will be a matter of trial and error, but be prepared to go on practising; remember that no talent, however great, can suffer the blight of neglect. I have spent many years trying to control watercolour and most of what I have learnt has developed out of constant practice. In fact, the medium seems to have a mind of its own, which makes it even more of a challenge for me. The excitement comes from not fully knowing what it will do each time I paint.

Five basic skills

Whether you are a beginner or a painter with some experience, the five methods and skills that I have focused on in this book will help to improve your abilities as well as build your confidence. They are large washes, achieving transparency, wet-into-wet, soft darks and hard lights and bold brushwork, used separately or in combination. Over years of teaching I have found them to be accessible for all levels of painter and flexible enough to help in developing a personal style. For me the joy of watercolour comes from the practice of these skills and knowing where and how to use them.

◀ **Winter Canal, Venice**
29 x 48.5 cm (11½ x 19 in)

I started this painting with broad washes of blues and yellows over the entire paper surface. When these were dry I painted in the bridge and worked outwards from this, trapping the light edges around the boats and using soft darks for the windows and single strokes of the brush for the posts.

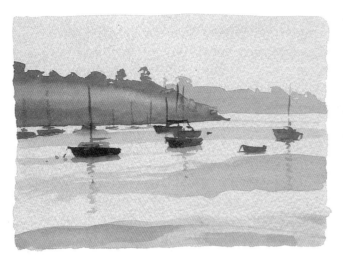

▲ Here I have painted a scene over a flat wash of Cobalt Blue. All successive colours were laid on top after it had dried thoroughly. The atmosphere is one of calm.

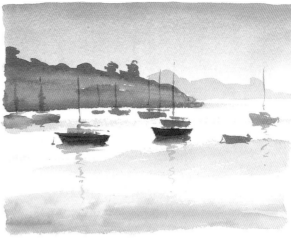

▲ In this version of the same scene a graded rather than flat wash of Cobalt Blue was laid first. This adds more depth to the sense of perspective and creates an air of mystery.

Large washes

I often start a painting with a large wash covering the whole of the paper surface, allowing colours to run freely together and mix on the paper, a simple procedure often referred to as the *première coup*. This gives one a feeling of control over that daunting piece of white paper and brings great excitement initially. I paint from top to bottom and from left to right (I am right-handed), bringing in colours as I need them. You will find that with practice you can get the colours you want in precisely the right positions without any contours or patches. Use plenty of water and have your washes of colours ready-mixed before you begin.

It is best to use no more than three separate colours in the *première coup*, otherwise successive washes may turn to mud. Keep your colours fairly pale and remember to wash out your brush in between the application of each colour.

As you gain more control over your use of watercolour you can choose to put down flat or graded washes. For a flat wash, which is a single colour of the same dilution, load your brush with plenty of colour; if your brush is too dry it will produce a streaky effect, and if it is too loaded with paint – which is to say, dripping – you won't be able to control it. Place your brush at the top left-hand corner of the paper and work horizontally to the right (if you are left-handed you may feel more comfortable working in the opposite direction). It is best to have your board at a slight angle of approximately 15 degrees so that a bead of liquid forms on the lower edge of the wash. With your next stroke, pick up this bead and continue in the same way, topping up your brush with paint from time to time as necessary.

A graded wash is a little more difficult to handle. Once again start at the top left, this time with a darker concentration of colour, then add a little more clean water with each stroke to lighten the mixture and graduate it until there is no colour in it at all.

Practise these washes a few times until they come easily, remembering that the more water you dilute your paint with the lighter the colour will be. With pale colours large washes are relatively easy; it's the darker ones that need more practice because the ratio of water to pigment is more critical, especially to realize transparency. Use plenty of water and plenty of pigment in the darker washes so that the bead of liquid is kept high on the paper surface, as this fluid treatment will increase the transparent effect.

Achieving transparency

Watercolour is a transparent medium, and laying a second wash over one that has already dried will allow you to see both. This is a relatively easy effect to achieve, but it does require patience and an understanding of drying times. All too often I have hurried on and disturbed a drying wash with another, creating a patchy, washed-out look and no transparency, instead of waiting until my first wash was dry and only then applying a second.

So, armed with this piece of knowledge and with your large wash thoroughly dry, apply a second one over the first. This will allow the colour or colours underneath to show through in what I call the window effect. Don't scrub on your second wash or you will lift the wash underneath. Let the second wash dry and you will be able to see the first wash below. I think that some of the best transparent glazing comes in the second and third washes on a painting; any more and the effect starts to become muddy or grey.

▼ ▶ When an initial colour is allowed to dry thoroughly before a second is overlaid the transparency that is characteristic of watercolour is preserved and a third colour is produced.

Aureolin + Cobalt Blue

Crimson Alizarin + French Ultramarine

Yellow Ochre + Coeruleum

Crimson Alizarin + Prussian Blue

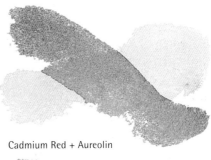

Cadmium Red + Aureolin

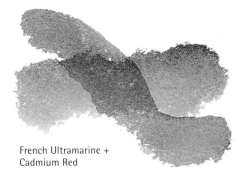

French Ultramarine + Cadmium Red

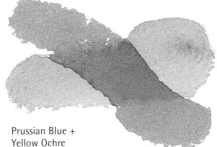

Prussian Blue + Yellow Ochre

Wet-into-wet

In this technique, colour is applied either to paper that has been dampened with clean water or to a previous layer of paint that is still wet. This very simple method of dropping in colour can produce some astonishing and unique effects, among them 'run-backs', or 'cauliflowers', where a dark, crinkled edge appears around the colour you have just added. While these can be deliberately induced for textural effects, the way to prevent them happening by accident is to use slightly less water in the dropped-in colour; do not disturb a drying wash with a very watery one. It is useful to let the sheen of water go off the paper before applying another colour. Remember that mastery of wet-into-wet comes with controlling the amount of liquid in the brush.

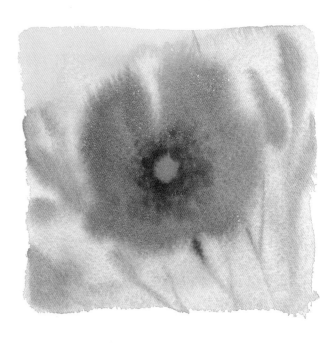

▲ First a wash of Yellow Ochre was laid down and when the shine had gone off the paper Cadmium Red was dropped in for the poppy with the point of a large brush so that it merged with the background. The foliage was put in with Coeruleum, which mixed on the paper with the Yellow Ochre and became green. The dark centre of the poppy was a mix of Cadmium Red and French Ultramarine.

▼ **The Blue Shutters, Provence**
50 x 79.5 cm (19³⁄₄ x 31¹⁄₄ in)

In the South of France I came upon this house with the blue shutters that are so typical of the region. I used a lot of wet-into-wet in this painting: the sky and trees, the windows and shutters in the shade and the foliage and flowers across the front of the picture were all put in with this technique.

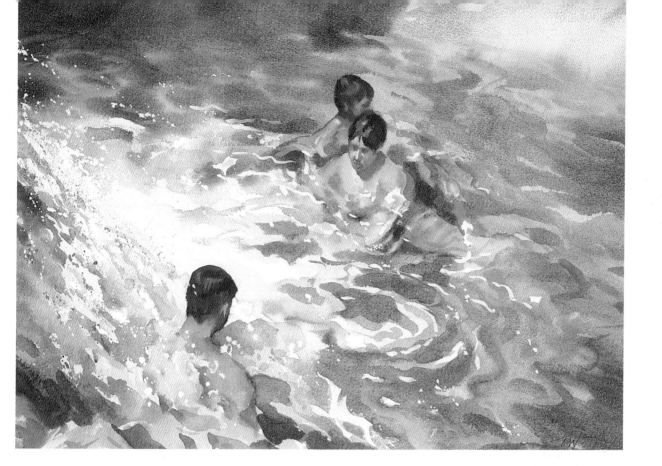

Soft darks and hard lights

This method of applying paint is very similar to wet-into-wet technique but slightly trickier. It requires you to think about two things simultaneously: describing a hard light edge and then dropping in a darker colour beside it which will look soft in comparison. This method gives you a greater ability to describe edges, both light and dark, and helps to keep the freshness in a painting.

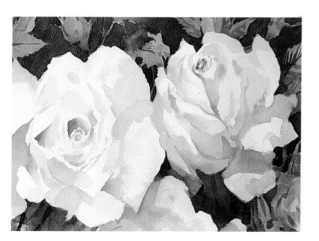

▲ **The Waterfall**
50 x 79.5 cm (19 ³/₄ x 31 ¹/₄ in)

In this painting of boys swimming in a waterfall in the Ardèche the hard light areas form the crisp white in the water and these are balanced by the soft darks in the background.

First apply an intermediate (half-tone) wash around the describing edge, then drop in darker colour to describe an object or shadow behind. I have found this method extremely useful, especially in floral paintings. It allows you to define a hard shape while at the same time painting the background (known as negative painting) instead of building up the darks with successive washes or leaving them all until last. In fact, putting in a dark tone at the beginning is helpful in establishing the tonal relationships in the painting as a whole.

◄ In this detail of *Rose Cascade* (see page 25) you can see the crisp, light edges of the petals contrasting with the soft darks of the foliage and background. Darker dilutions have been dropped wet-into-wet into the background.

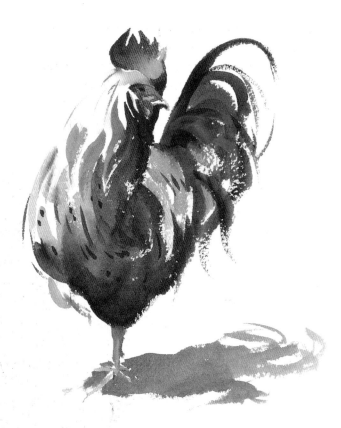

Bold brushwork

The way in which the brush is used in a watercolour is a telling signature of the artist. The brush works in a variety of different ways its wonders to perform. It can produce shape as well as line; if you accustom yourself to pushing and pulling the brush you can create volume, both light and dark, in one stroke (see pages 30–1). The brush can also hold more than one colour at a time and will respond to amounts of liquid in a telling way. If you can get the brush to work well under your hand that will produce confidence and boldness in your painting. Differences of pressure are the keynotes, but using a light touch is a skill that needs a good deal of practice.

Remember that economy of brushstroke creates simplicity and directness. Why use 10 strokes of the brush when one would do? However, wet or dry, it is the confidence of the stroke which is critical, so practise with your brushes and find out what they will do for you.

▲ You can clearly see the brushmarks in this painting of a cockerel. The brush was used as a drawing tool to indicate the shape of the body and to suggest the texture of the feathers.

▶ **The Potted Garden**
30.5 x 30.5 cm (12 x 12 in)

I started this painting with a large variegated wash of French Ultramarine, Cadmium Orange and Yellow Ochre and allowed it to dry thoroughly before painting in the subject matter with bold, confident brushstrokes.

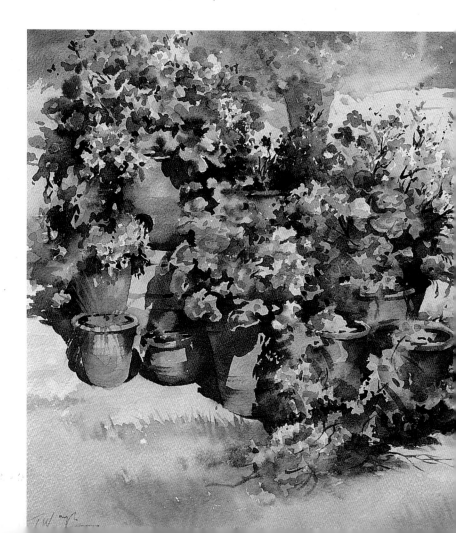

Practising your skills

As you become familiar with these five methods and skills you will gain confidence with the medium. It is very difficult to improve your skills if you only paint once or twice per year, as each time you start it it will be like beginning from scratch. Try to set aside some regular time for painting – little and often is best if your time is limited – and you will soon notice the benefits. When you are painting you can choose to concentrate on two or three of these methods and incorporate them with techniques you already know, or you can combine them all to create your own individual style.

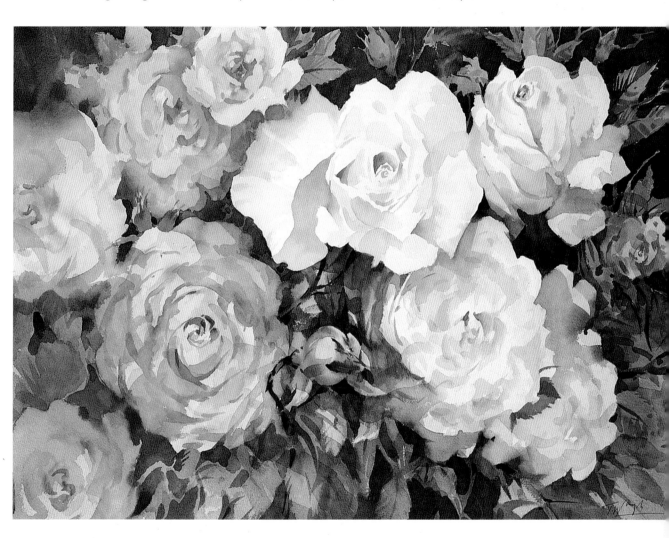

▲ Rose Cascade
51 x 76 cm (20 x 30 in)

This painting shows the five methods and skills in combination. I started with a large wash of pale colours covering the entire surface then, after allowing this to dry, worked outwards from the centre of the main rose using direct brushwork. Large washes were used to create the background foliage and soft dark values were dropped in wet-into-wet. The transparent shadows were put over as glazes after the painting had dried.

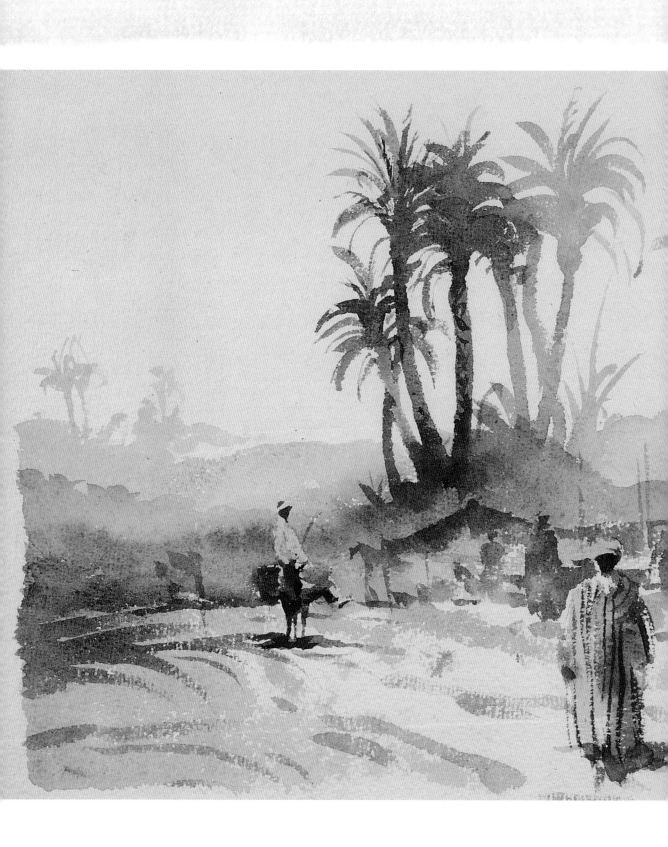

Drawing with a Brush

The quality and confidence of your brushwork is vital to the success of a painting. I have spent many a happy hour just painting with one or two colours and giving myself only 6–10 brushstrokes to develop each subject. In this way, when one mark is made, it automatically suggests the next. This economy of brushstrokes applies the mind to the task and helps to produce a painting with simplicity as well as directness. I regard the brush as the main tool in creating a successful watercolour; it can bring sparkle and dazzle to an otherwise boring subject, and there is nothing more lovely than a flat wash of colour peppered with calligraphic marks.

Working in monochrome

This chapter is illustrated with tonal, or monochrome, artworks. One of the benefits of this way of working is that it allows you to concentrate on developing your brushmanship without having the added complication of worrying about the colours you are using. It is possible to create different textures and shapes by simply using a round brush with a good tip, and practising brushstrokes in monochrome will give you the skill to introduce an infinite variety of application in your painting. Also, apart from practical considerations, monochrome artworks have a simple beauty that I find most enjoyable.

◀ This page from my painting journal shows a Moroccan village. It was painted freely with a large round brush. By employing the tip and the body of the brush I was able to achieve a variety of shapes easily.

The single stroke

In my opinion, the single stroke of the brush reigns supreme; it has more freshness and immediacy than brushstrokes that are overworked or manipulated and can be a powerful way of indicating movement, or a sense of direction. Add variety to your brushwork by finding different ways of using the brush in the single stroke, as this will bring life to a painting. Brushwork should be both virtuoso and expressive; if your brush is fully loaded you will find it possible to paint a complex shape in one hit without lifting the brush off the paper. In large mass areas such as foliage, individual leaves or branches can be picked out with single brushstrokes.

◀ This Venetian post was painted in two strokes of the brush. The top and bottom half of the pole are divided by blank paper which combines with the two painted shapes to form a whole in the eye of the viewer.

▼ The gondolier was painted in one hit, with a single stroke added to indicate the pole. The near side of the gondola was done with another stroke, followed by the shadow. The far side of the gondola and the passengers were accounted for by another stroke, and a final brushtroke put in the covered section of the bow.

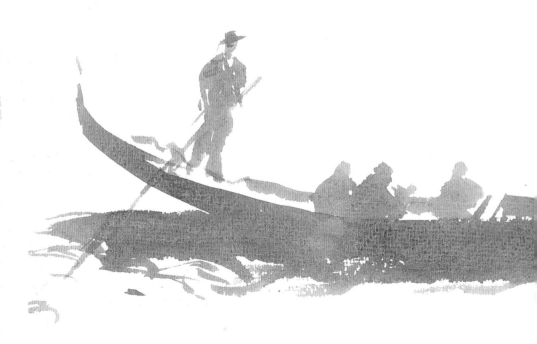

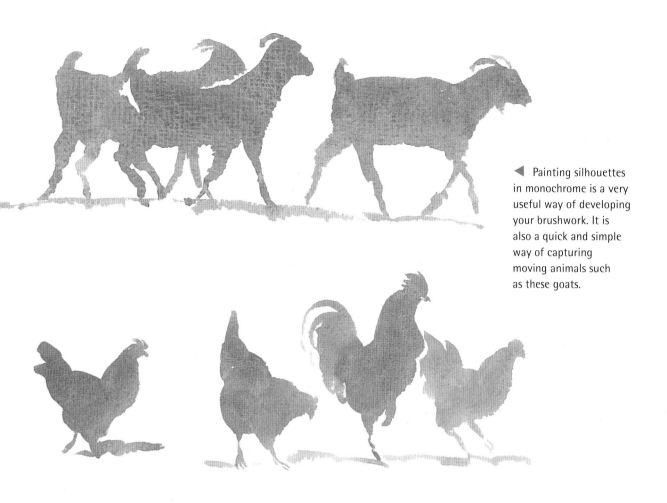

◀ Painting silhouettes in monochrome is a very useful way of developing your brushwork. It is also a quick and simple way of capturing moving animals such as these goats.

▲ These chickens were painted in silhouette, using the tip and body of a large round brush.

Using the whole brush

The brush is a reservoir for holding liquid, the body of the brush feeding liquid to the tip. A round brush that has a tip as well as a body is useful because with a simple stroke you can create marks that go from thick to thin or pale to dark, depending on the pressure you apply and how much of the brush you use. The hairs can be split and dragged for dry brush technique, and the end of the handle can even be sharpened and used to draw lines.

A brush can also be used as a tool for printing; you can create a fixed shape with a damp soft brush by splitting the hairs or moulding them with your fingers and then press the shape repeatedly over the surface. Try using your brushes for as many effects as possible.

Dry brush technique

Dry brush technique is self-explanatory; it is largely the action of dragging the brush across the surface of the paper so that the paint skips over some areas and covers others. Load the brush first and then reduce its liquid content by dabbing on a towel or cloth. Test out the brush first before using it on your painting. The dry brush technique is useful for producing texture and sparkle in your paintings, and is particularly suitable for creating the effect of light on water and objects with broken edges.

▶ Here I have dragged the paintbrush across the paper with very little liquid in it, so that the resulting shapes are broken. This form of dry brush technique can produce both texture and sparkle.

Building shapes

A good-quality round sable brush can produce line with its tip and shape with its body. More importantly, used with a combined push and pull technique it can easily manage both; this can describe the inside and outside of a shape in the same stroke. Its flexibility as a tool is seemingly endless. Volume can be created if you push harder with a fully loaded brush, when the mixture generally lightens. As you pull off the paper the tip will release more

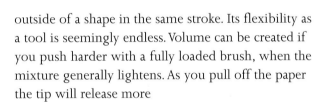

▲ Block shapes in this sketch of a Moroccan kasbah show the divisions between light and dark in the buildings and the simple silhouettes of the palm trees together with their cast shadows.

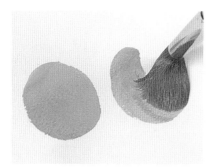

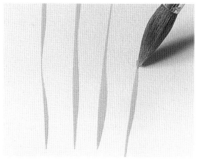

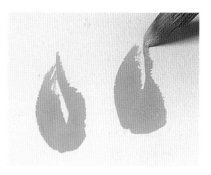

▲ Using a large round brush, paint a circular shape in one continuous movement by pushing the brush.

▲ Use just the tip of a large round brush and a firm pulling movement to produce line.

▲ Combine pushing for shape and pulling for line to create quite effective leaf shapes.

liquid, resulting in dark and light in one brushstroke. Try practising painting shapes in this way, rather than filling in an outline.

Everything in nature can be described with some kind of shape: large/small, thick/thin, soft/hard, broken/continuous. Take a look at each shape you are painting and then allow yourself to translate, or interpret, with the brush. Don't try to get it right, just try to get it.

It is important to pay attention to the size of the shape you are painting and its relationship to the scale of other shapes within the picture. These relationships between shapes are most important in creating a sense of reality.

Direction

You can direct the eye through a painting by the use of the brush and the kind of shapes you employ. For instance, in the study of a cottage at Chastleton (right) the direction of the grasses moves the eye up towards the cottage and the curve of the path leading to the doorway. This sort of direction with regard to shape can create movement in an otherwise rather static subject.

Look for the flow of shapes in a painting and use the brush in the direction of that flow. In skies, for example, cloud shapes are generally larger and more amorphous at the top and gradually become stretched out and smaller at the horizon. With water, the shapes are active and choppy in the foreground and become passive and thinner as they recede.

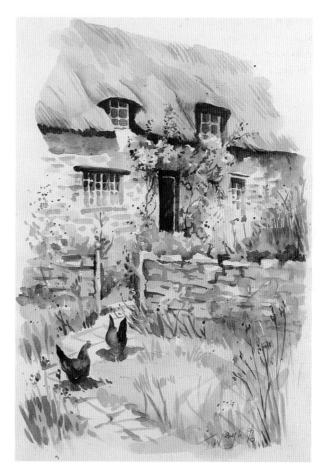

▲ In this monochromatic study I made of a cottage in Chastleton in Oxfordshire the direction of the brushwork and block shapes leads the viewer's eye from the grassy foreground through the open gate to the doorway and above, then out of the picture.

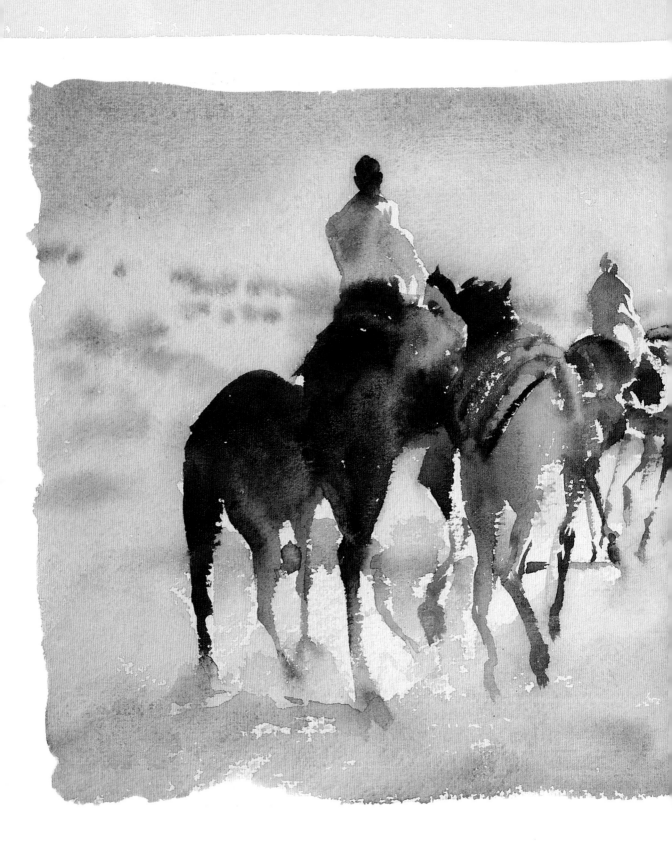

Sketchbook Beginnings

I take a journal or sketchbook with me wherever I go. It is important to get the creative juices flowing right from the genesis of a painting, and the journal brings back all the excitement of the subject as it was seen for the first time. Photographs, although expedient, always seem to disappoint; the wonderful scene or colours that I remember often seem to have lost something when the photograph comes back from processing, but in the journal that initial impression is captured. I have several types of painting journal, all consisting of watercolour paper either stitched or perfectly bound and with a hard-backed cover, as well as other books with drawing paper for pencil sketches.

Thinking ahead

When I am working in the journal or sketchbook I often make compositional notes for a later finished painting. Sometimes there can be several alternatives, taking the form of quick scribbles, or thumbnail impressions; these are roughly organized in horizontal, vertical or square formats. These notes are invaluable to me when I have to start getting a number of paintings ready for an exhibition. I look to my journal for inspiration and to any photographs I have taken for general reference and accuracy of detail.

◀ This is a page from one of my journals. What interested me in the scene was the way the heat affected the colour and atmosphere. The white of the paper was used for portraying the bright light, keeping the sketch fresh.

Inspirational sketches

I paint a lot of vignettes in my journals so that I can later make decisions about any finished painting that they inspire. I try not to limit myself with edges or a specific boundary but take the opportunity to paint freely, often starting at a focal point and working outwards. Each item is therefore finished whenever I stop and is limited only by the size of the page. I like to keep the work simple, as it leaves room for interpretation at a later date.

I also find it useful on some occasions to employ just one colour, with three tones: dark, half-tone and the white paper as the light tone. This is simple and exciting, and also extremely practical as I need only the journal, one brush and one tube of paint to go on my travels. I concentrate on painting shape as silhouette with the half-tone first, painting around any highlights, then brush in the dark values when this has dried.

The sketchbook gives you a place to practise brushwork, an essential skill for the committed watercolourist, whether a novice or a more experienced painter. Here you are able to try out new ways of working without any pressure to achieve a good finished result. The immediacy of the brush is often calligraphic in nature, forcing you to use simple shapes. Bold strokes of the brush can produce a poetic rhythm and spontaneity that is unique and no subject is beyond this treatment, be it a collection of twigs and stones or the Grand Canal in Venice; whatever may inspire you at the time.

I often feel a sense of urgency and numerous apparently unrelated subjects can appear on one page of my journal. This can be due to the transience of the weather conditions or just how much time is available to me in a particular place; speed with accuracy is my motto.

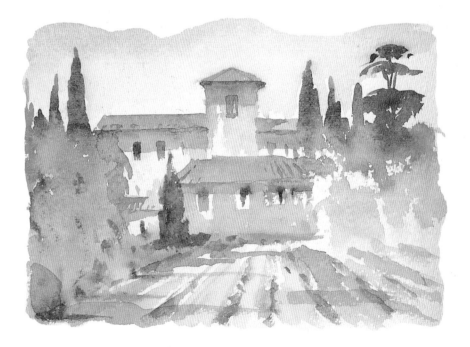

On a visit to Florence I was struck by the beauty of the Tuscan landscape. The wonderful colours seemed to drift and melt endlessly into one another, and it was a perfect setting for inspired watercolours. These three paintings from my journal recall the light and colours of the region. With a few simple brushstrokes, I attempted to capture the feeling of timelessness.

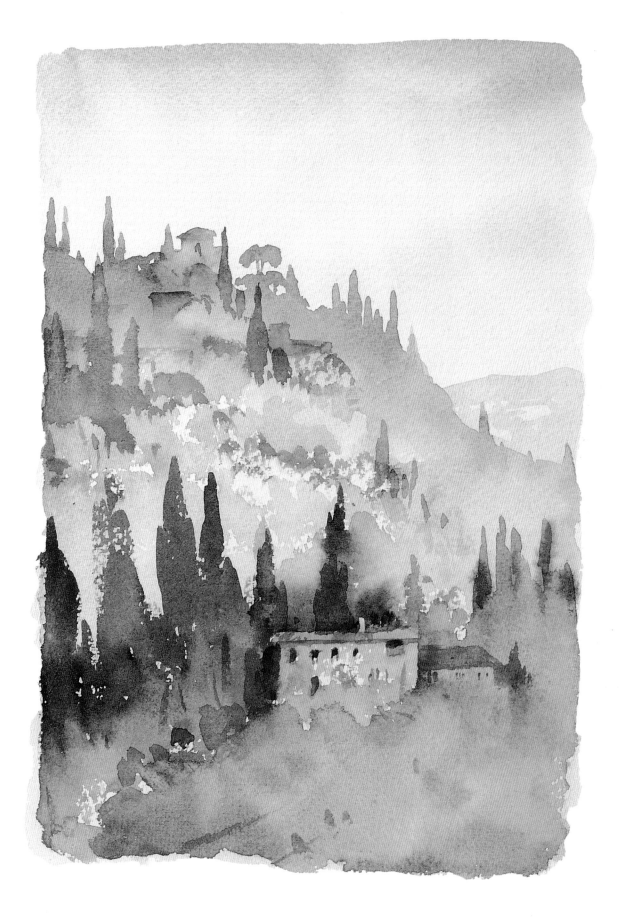

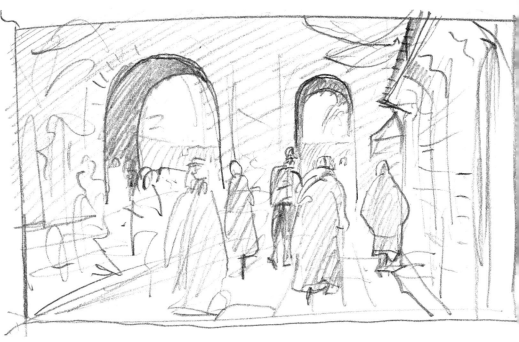

▶ When you are looking at figures in a street scene you need to establish which figures are important. Here, in a street in Essaouira, Morocco, I decided that the hunched old man played a key role in the composition.

Reference sketches

Observation plays a major role in sketching for later reference, using either pencil or watercolour. When sketching with the pencil I tend to use continuous line; in other words, I keep my pencil on the page and as my eye observes a subject the pencil follows.

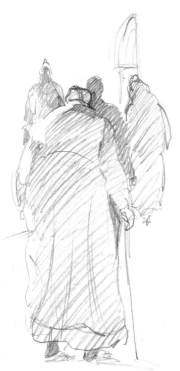

◀ Because the old man was to be a focal point in the composition I made a separate sketch of him. Note the interlocking shapes of light and dark throughout the picture.

This helps to capture the movement of the subject; a useful hint is to let the pencil go slow on the angles and straight lines and faster on the curves. Don't spend time considering composition at this point – that comes at a later stage.

Look carefully at proportions, for example the size of head to body if you are sketching a figure, or of tree to building in a landscape. Correct proportions are essential for the success of a later painting. Forms in nature are not disconnected; one contour invariably overlaps another.

The fundamental difference between the pencil and the brush is that while the pencil is ideal for describing contour, the brush is ideal for describing shape. The ability to draw well and with enthusiasm is critical to a successful painting as, in essence, a painting is a combination of both drawing and painting. Your sketch, whether in pencil or watercolour, should reflect the positive and negative shapes and how they interlock. I spend a lot of time when I am sketching deciphering these shapes so that when I come to the painting stage I have a clear idea of them. The use of positive and negative shapes and how they combine with one another can produce excitement in a painting.

There are many ways of using the reference that journals and sketchbooks provide other than in a

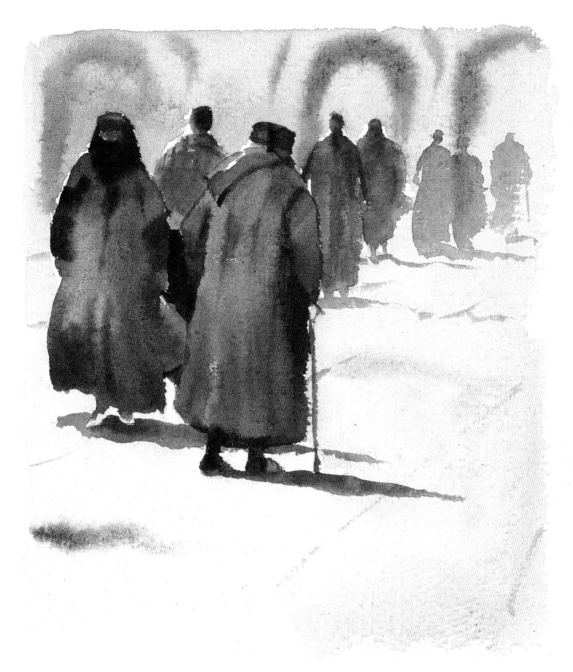

specific painting for which you have worked out preliminary ideas. For example, you may be sitting outside on a beautiful day painting a cottage garden with hens scratching around it and find that you have to pack up early because it has started to rain, or you've run out of time, or the light is fading. Back in the studio, you realize you hadn't yet painted in any of the hens. However, you do know the breed and all those hours spent previously studying hens and their habits means you can go to a sketchbook to check on their proportions and behavioural attributes and add them to your painting.

▲ I continued to paint the old man long after he had left the scene, as I could refer back to my earlier sketches. In this watercolour sketch, I formalized my ideas for a finished painting called *A Street in Essaouira*.

If you live in an area with a changeable climate the vagaries of the weather can make your reference material very handy. When you are painting abroad reference is essential – it is not so easy to pop back to Morocco or Tennessee, for example, to get another look!

Using a sketchbook

- Take a sketchbook with you wherever you go.

- Make compositional notes or thumbnail impressions.

- Practise your brushwork.

- Look at how positive and negative shapes work together.

- Record what excites you – don't worry about a finished result.

- Use your sketchbook as inspirational reference in finished work.

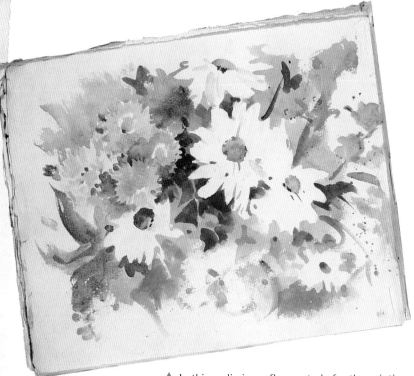

▲ In this preliminary flower study for the painting *The Cornish Jug* I wanted to capture the freedom in the arrangement of the shapes and colours. I painted quickly, using a large round brush, capturing just my initial impression of the subject.

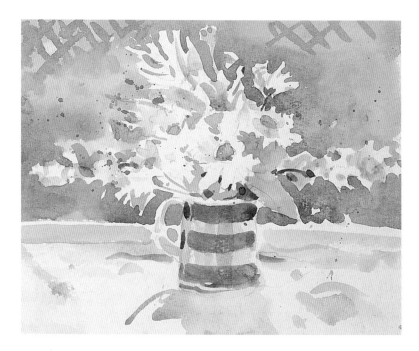

▶ In this thumbnail compositional sketch I concentrated on the mass areas and arrangements of light and dark shapes, leaving the details to the finished painting.

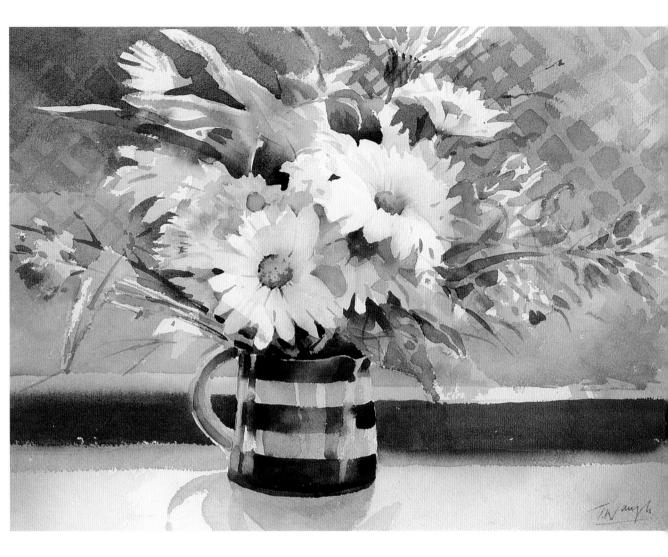

▲ The Cornish Jug
29 x 48.5 cm (11½ x 19 in)

As a result of my preliminary work in the sketchbook I was able to be more spontaneous and concern myself with painting the light and how it affected this jug of flowers on my window ledge at home. The most interesting elements were the reflected light and shadow patterns created by the window and the shiny surface of the jug.

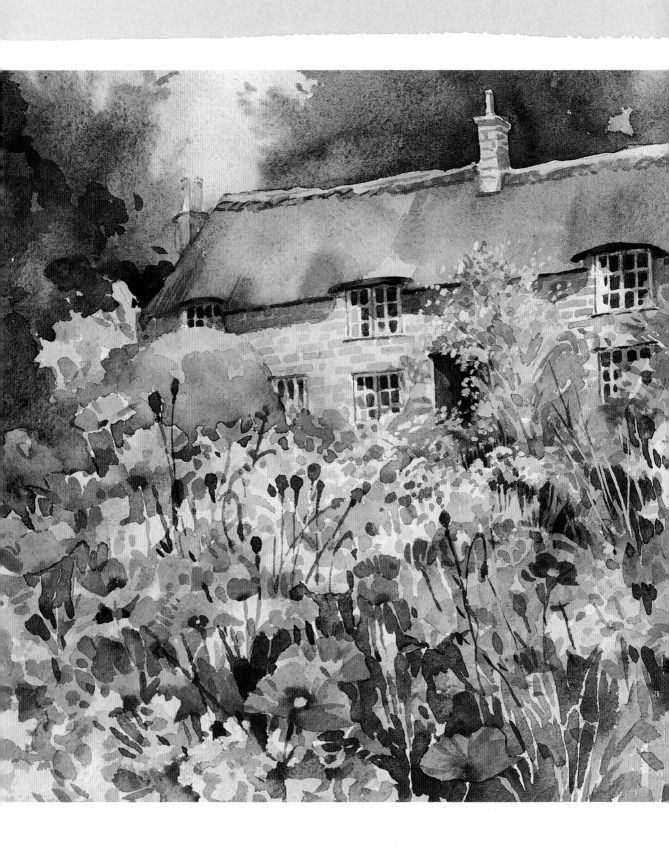

Choosing a Colour Scheme

Colour is one of the aspects of painting that excites me the most. I love the way colours interact with each other and how they are affected by light and shadow. Choosing the colours for a painting from the almost infinite number of combinations available can be confusing, but I find it often helps to think of a painting as a room and then choose a general 'colour scheme' for it. Interest and variety can be woven into each individual painting by adding other colours to the basic colour scheme you have selected. It is important to have accents of colour in a painting and if you regard subject matter as 'furniture' in your room it will be easier to place these appropriately.

Observing colour

The very first thing you must do as a painter is train yourself to see colours, for it is only when you have learned to discern them properly that you will be able to paint them. The colours of nature are richer and more varied than they appear to be from a casual glance; if you look carefully at the sky, for example, you can see all the primary colours – red, yellow and blue – present in a dilute form.

◀ **Cottage Garden**
32 x 45.5 cm (12½ x 18 in)

The colours in this garden and cottage are made to appear stronger by the neutral greys and blues in the background. I used Cadmium Red and Cadmium Orange for the warm colours of the poppies. Where the red becomes colder in the mid-ground the colour is Rose Madder Genuine diffused with French Ultramarine.

The colour circle

Colour theory can be complex, so I have limited this chapter to aspects of it that I feel are particularly beneficial to watercolour painting. I use the primary colours – red, yellow and blue – from the tube, but I prefer to mix secondary colours such as purple and green myself, as I find them softer and more flexible than proprietary colours. The only secondary colour I consider invaluable from the tube is Cadmium Orange. I prefer its performance and intensity of colour compared to an orange you can mix; it also mixes well with other colours without becoming muddy.

In each of the primary colours there are both cold and warm categories – see the six-colour palette on page 47 for an example. Warm and cold colours are a useful tool for moving an object nearer or further away in a painting, as warm colours advance and cool colours recede (see page 84).

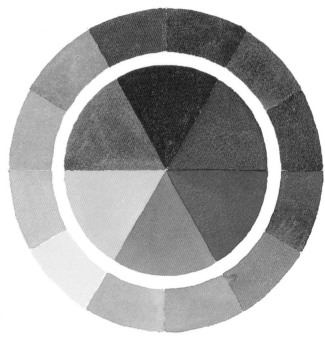

▲ The inner circle shows the three primary and the three secondary colours, while the outer circle shows warm and cool versions of each colour.

Colour relationships are important and an understanding of these is essential. They fall into three major categories: complementary colours, which are directly opposite one another in the colour circle; contrasting colours, which are next door but one to each other; and harmonizing colours, which are adjacent. These relationships can produce dazzling and subtle effects in the right hands. For example, red poppies in a green field give you the opportunity to play with complementary values; a red sail against a blue sky

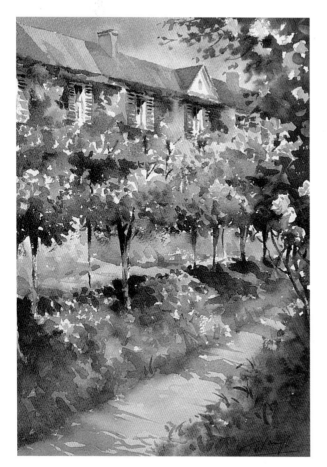

◀ **Monet's Garden**
33 x 23.5 cm (13 x 9¼ in)

This painting shows a riot of warm and cool colours. The warm path and flowers in the foreground are set against a backdrop of a cool sky and roof and are draped with warm and cool shadows. The pink on the walls of Monet's house was made cooler by adding in a tint of Cobalt Blue to the Vermillion (Hue).

is a contrasting arrangement; and the yellows and oranges in a sunset harmonize. There is no substitute for experimentation with colour; experience always wins over technical information.

Tertiary, or earth, colours are truly important to the watercolourist, and these are basically the siennas, ochres, umbers and browns. Neutral colours are black, white and grey. It is sometimes necessary to reduce the intensity of a colour yet keep its tonal value. This is when neutrals are useful, but be careful not to add too much black to a painting or it will dominate and kill off your colour relationships.

Colour properties

The properties of individual watercolour paints vary from one to another, depending on their chemical formulas. These properties – granulation, transparency, semi-opacity and opacity – describe the effect of the colour. Some colours have more than one property; Raw Sienna, for example, is both transparent and granular. These properties can be used to your advantage to create texture, smooth or granular, in your painting. As you gain familiarity with your paints you will begin to take into account their properties as well as their colour.

◀ Watercolours that show the property of the paints are a delight to look upon. The granular effect produced by this graded wash of French Ultramarine shows both texture and transparency.

▲ Here I have applied a graded wash of Crimson Alizarin (transparent), Yellow Ochre (semi-opaque) and Cadmium Red (opaque). Their different properties lend a particular quality to the paint.

Mixing colour

There are several ways of mixing colour. I prefer the method of allowing colours to mix on the paper as much as possible because this creates a more vibrant result. If you mix colours on the palette they tend to lose their intensity, although it is sometimes necessary to do this. When you are mixing colours in the palette, try to limit yourself to two colour mixes at first.

Because watercolour is transparent, laying a wash of one colour, allowing it to dry thoroughly then laying another colour on top creates a third colour. Combinations of these different methods of mixing can produce virtuoso effects and are often a signature of the artist's work.

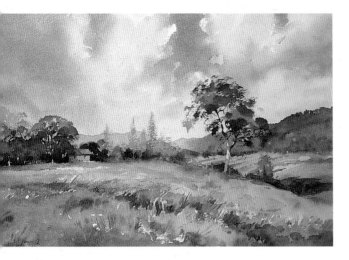

▲ **Ardèche Landscape**
33 x 49 cm (13 x 19 1/4 in)

Most of the colours in this painting were allowed to mix on the paper. However, some of the greens in the trees and the foreground were mixed in the palette from French Ultramarine and Raw Sienna.

▼ The colours shown below are examples of the effect obtained by allowing colours to mix on the paper. Used thus, they combine to give a fresher result than when mixed in the palette.

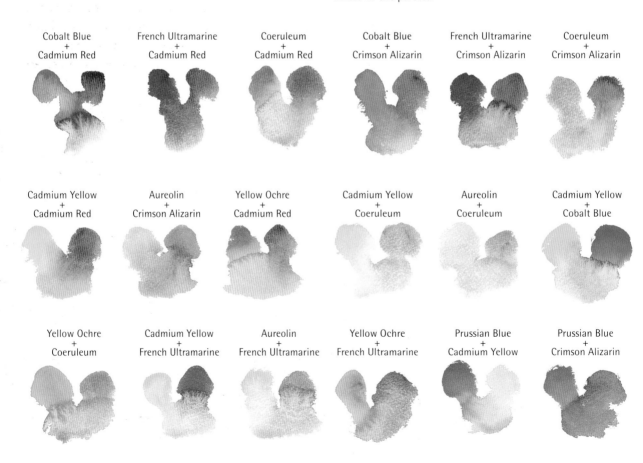

Cobalt Blue + Cadmium Red

French Ultramarine + Cadmium Red

Coeruleum + Cadmium Red

Cobalt Blue + Crimson Alizarin

French Ultramarine + Crimson Alizarin

Coeruleum + Crimson Alizarin

Cadmium Yellow + Cadmium Red

Aureolin + Crimson Alizarin

Yellow Ochre + Cadmium Red

Cadmium Yellow + Coeruleum

Aureolin + Coeruleum

Cadmium Yellow + Cobalt Blue

Yellow Ochre + Coeruleum

Cadmium Yellow + French Ultramarine

Aureolin + French Ultramarine

Yellow Ochre + French Ultramarine

Prussian Blue + Cadmium Yellow

Prussian Blue + Crimson Alizarin

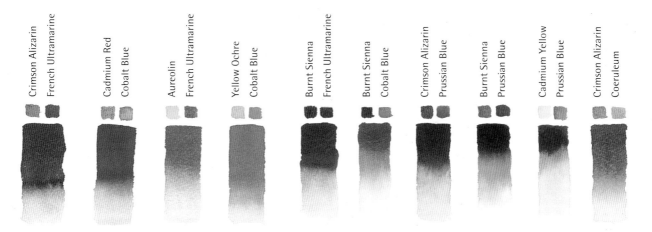

Crimson Alizarin / French Ultramarine Cadmium Red / Cobalt Blue Aureolin / French Ultramarine Yellow Ochre / Cobalt Blue Burnt Sienna / French Ultramarine Burnt Sienna / Cobalt Blue Crimson Alizarin / Prussian Blue Burnt Sienna / Prussian Blue Cadmium Yellow / Prussian Blue Crimson Alizarin / Coeruleum

▲ These are examples of two-colour combinations thoroughly mixed in the palette to produce a range of useful dark colours.

Mixing colours in the palette creates a smooth result, but the colour can sometimes lack freshness.

The palette and the painting

As your palette is the source of your painting, a muddy palette leads to a muddy painting and conversely a clean palette gives a clean painting. Try to keep your palette as clean as possible if you want a colourful result. You can never have too much mixing space, so use large palettes with a combination of deep wells and flat surfaces. Having several palettes available is better than just one, as it removes the temptation to paint on with a dirty palette.

I often say to my students, 'If you're going to win a war you need to have a plan.' In other words, you need to prepare your palette before you start painting. There is nothing worse than having to stop halfway through a large wash to make up another dilution of the colour you are using; by the time you have done this the wash will have started to dry and hard lines or patches will appear when you add more paint. Having chosen your colour scheme, you can prepare your palette accordingly and make sure you have plenty of the colours you will be using ready diluted.

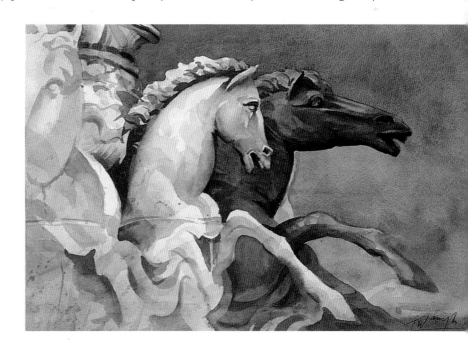

▶ **Neptune's Horses**
34.5 x 51 cm (13 ½ x 20 in)

I used limited colours to capture the creams and browns of this marble sculpture in Florence, mixing most of them in the palette. This had the effect of slightly subduing the end result, which I used to convey the patina of the marble.

The four-colour palette

Sometimes it is appropriate to work with a limited palette, which allows you to concentrate on tone and texture. It also offers you an opportunity to create a timeless effect. When I was travelling in the USA I spent some time on the Cherokee Reservation in Tennessee. I wanted the paintings that I did there to be evocative of the turn-of-the-century sepia photographs of Native Americans that I had collected on postcards as a boy. A limited palette created that feel without being simply monochrome.

Cadmium Orange

French Ultramarine

Cadmium Yellow

Burnt Sienna

▶ **Live Bear**
48.5 x 29 cm (19 x 11½ in)

In this portrait of Live Bear I used Cadmium Orange, Cadmium Yellow, French Ultramarine and Burnt Sienna. The warm silhouette of his features is thrown into relief by the darker, colder trees in the background. I was keen to paint the different textures of his face, the softness of the feather headdress and the fir trees. Using large washes, I glazed over the feathers and applied a concentrated mix of French Ultramarine and Burnt Sienna wet-into-wet for the soft darks in the treeline.

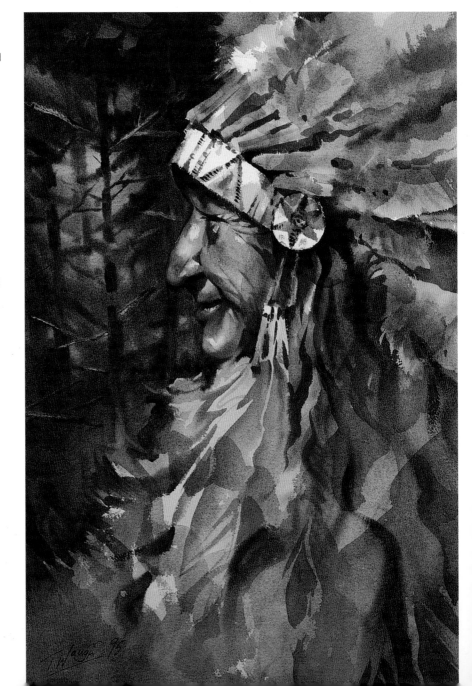

The six-colour palette

A six-colour palette, although seemingly limited, can provide an opportunity for you to explore all the colours and the mixes available from a split primary set of two reds, two yellows and two blues. For example, Cadmium Red and Crimson Alizarin, Yellow Ochre and Aureolin, French Ultramarine and Coeruleum give you a warm set of primary colours and a cool set. The mixes you can make from these six colours can give you the whole colour circle to play with.

Yellow Ochre Burnt Sienna French Ultramarine

Naples Yellow Cadmium Red Coeruleum

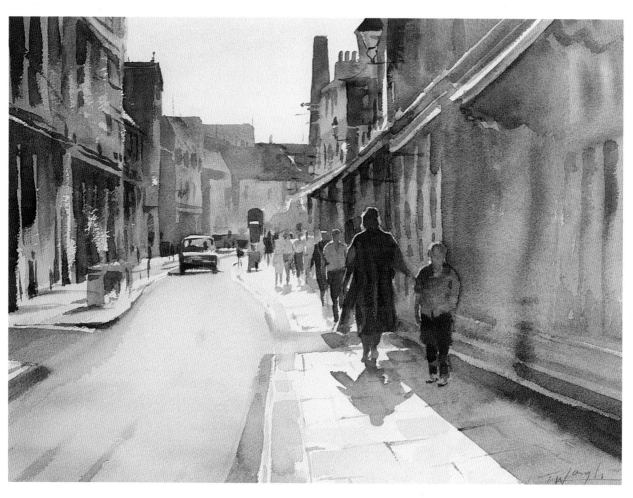

▲ **Plymouth Street Scene**
30.5 x 48.5 cm (12 x 19 in)

For this Plymouth street scene I used French Ultramarine and Coeruleum, Burnt Sienna and Cadmium Red, Yellow Ochre and Naples Yellow. In this split primary palette Burnt Sienna acted as my warm red and Naples Yellow as my cooler yellow. The combination of Burnt Sienna and French Ultramarine makes for powerful darks in a picture and you can alter the temperature of these by varying the amounts of each colour in the mix.

The ten-colour palette

When you become more experienced with colour it is rewarding to lay out a full palette, and a ten-colour palette will give you a complete range of coloration and tone. The exciting combinations that can be mixed from ten colours provide a chance to play with the nuances and properties that the individual colours contain. For example, Aureolin, a very acid yellow, is extremely transparent and can make vivid greens when mixed with blues.

▼ **Morning Sunlight, Venice**
29 x 48.5 cm (11½ x 19 in)

There were so many subtle colours in this scene that I decided to use an extended palette of 10 colours: Aureolin, Cadmium Orange, Naples Yellow, French Ultramarine, Coeruleum, Cobalt Blue, Crimson Alizarin, Cadmium Red, Burnt Sienna and Burnt Umber.

Aureolin

Cobalt Blue

Cadmium Orange

Crimson Alizarin

Naples Yellow

Cadmium Red

French Ultramarine

Burnt Sienna

Coeruleum

Burnt Umber

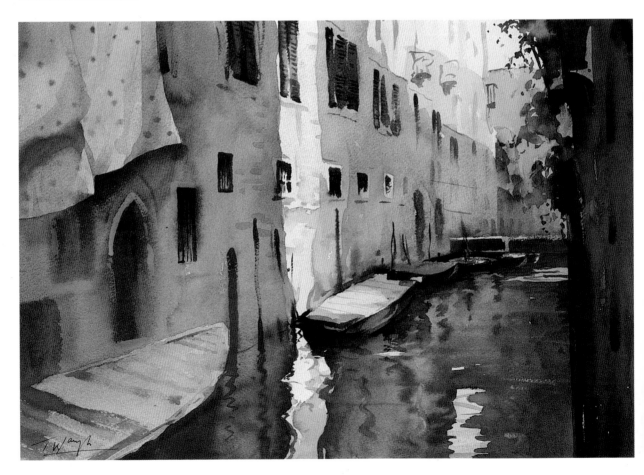

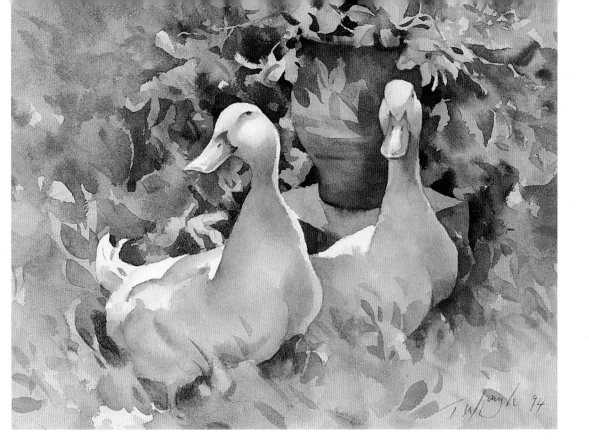

Colourful lights and darks

Try to think of all the tonal values in your painting as having a colour identity. There is a tendency to neutralize colours when going for darks, but greater intensity can be brought to your painting at this stage by considering the darker values as colourful rather than neutral.

Light areas can often take on a washed-out appearance if the dilution does not have enough pigment in it. Pure colour is more desirable than mixed colours for these lighter areas.

The ratio of water to colour is an important factor in keeping colour intensity and transparency. I like to keep the bead of liquid high on the paper and I do this by making up larger amounts of my dilutions than I think I am going to need so that I don't run out and end up spreading what I have too thinly to form a bead. This is especially vital in the dark areas, where if you haven't got the ratios of water to pigment correct you may achieve a patchy result. This is an indication to use more pigment and more water in your next painting. Plenty of water and plenty of pigment produces both luminosity and transparency.

▲ **Ducks and Strawberry Pot**
23 x 33 cm (9 x 13 in)

This is a painting of my ducks in the garden at home. Note that the shadows on the ducks are very colourful, mixed from combinations of Cadmium Orange, Cobalt Blue, Rose Madder Genuine and French Ultramarine. The dark accents around the ducks are intense, but still full of colour.

Demonstration A Cottage Doorway

Using a six-colour palette

MATERIALS

Brushes Round brushes No. 14
sable, No. 8 Diana Kolinsky sable
and No. 5 sable

Colours Aureolin, Coeruleum,
Crimson Alizarin, French
Ultramarine, Yellow Ochre,
Vermillion (Hue)

Paper Whatman 400 gsm
(200 lb) Rough

Other items Daler-Rowney
Educational Stacking Palette BB9;
lightweight board; 5 cm (2 in)
brown paper masking tape;
2 large water jars

▲ **STAGE 1**

I started with a large wash, using my No. 14 brush and covering the whole of the paper. Working from top left, I used French Ultramarine and then flooded in Coeruleum, a little Crimson Alizarin and some Yellow Ochre and Aureolin. Allowing the colours to mix together on the paper like this rather than in the palette is one way of keeping the colours 'clean'. Thinking ahead to where the foliage would be, I placed some Coeruleum and Aureolin together to make a background for the foliage. This type of initial wash is known as a variegated tinted background. I let it dry thoroughly then went straight in to my focal point, painting the red door with Vermillion (Hue) and a No. 8 brush. I picked up a touch of Aureolin from the palette to give a slightly warmer effect.

▶ STAGE 2

I allowed a darker concentration of Coeruleum and Aureolin to mix on the paper into the foliage area around the door, leaving small spaces from the pink background amid the foliage to begin to give the impression of flowers. Next I dropped a darker concentration of the green into the foliage in front of the door, using wet-into-wet technique. As I continued to work on the foliage around the door I kept dropping in dark areas, moving outwards from the focal point and creating an upside-down T shape.

▶ STAGE 3

I used the 'push for shape/pull for line' technique to suggest leaves and more detailed edges, then splashed on a few colours to create the spontaneity of the way flowers and leaves actually grow. They are not uniform in shape and splashing on paint by lightly tapping the loaded brush allows for variety.

▶ STAGE 4

Next I used the brush dry, pressing it into the paper so that the hairs splayed out and dragged colour across the dried wash. This gave a feeling of texture to the foliage.

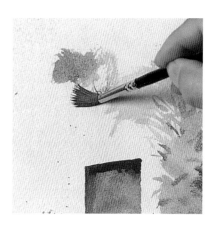

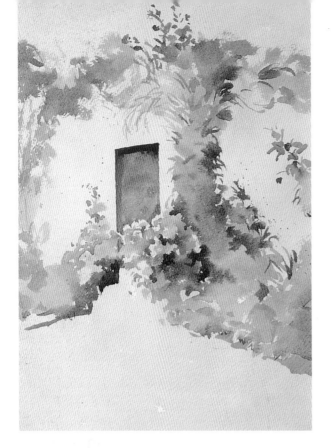

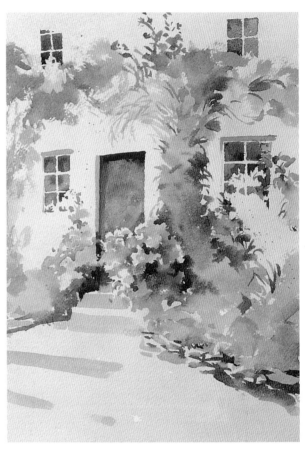

◀ **STAGE 5**

As I painted I left spaces among the greenery where the cottage windows were to go. I put in some purple towards the front of the flower border using a mix of Crimson Alizarin and French Ultramarine, created in the palette. A variety of brushstrokes were used in the foliage in order to create some interest. The mass area of the foliage was now mostly in place.

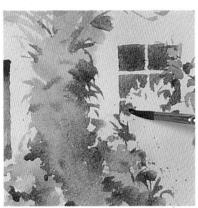

▲ **STAGE 6**

Next I put in the downstairs windows, painting the glass with a mix of Crimson Alizarin and French Ultramarine. I concentrated on the negative spaces, flooding in darker colours while the paint was still wet to create a sense of depth. I chose not to complete all the squares in a regimental fashion and left spaces where the foliage would come across.

▲ **STAGE 7**

The next step was to paint in the lintels of the windows and the steps with single strokes of the brush, paying particular attention to the recessed areas. I then painted the upstairs windows, first the one on the left, followed by the one on the right. I have noticed that the glass in the windows of Cotswold cottages always seems wobbly, so I constantly check the angle of the panes to get that feel in the painting.

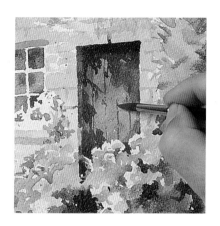

▶ STAGE 8

I painted in a few dark accents here and there across the picture to help with the sense of depth and tonal contrast. After putting in the recessed areas of the roof, I added a few details on the red front door using a darker red from a mix of Crimson Alizarin and Vermillion (Hue). I also strengthened the shadows.

▶ STAGE 9

Returning to my large brush, I painted a large wash across the foreground with Coeruleum and Aureolin, adding in some Yellow Ochre towards the front to help give a sense of depth. To finish the painting I added some shadows to create a passage throughout the picture. These were glazed across earlier layers of paint when it was thoroughly dry so that the colours beneath are visible. There are still some light areas remaining from my initial wash. The variety of colour mixes arising from some being mixed on the paper and some in the palette gives a rich and colourful outcome despite the limited palette.

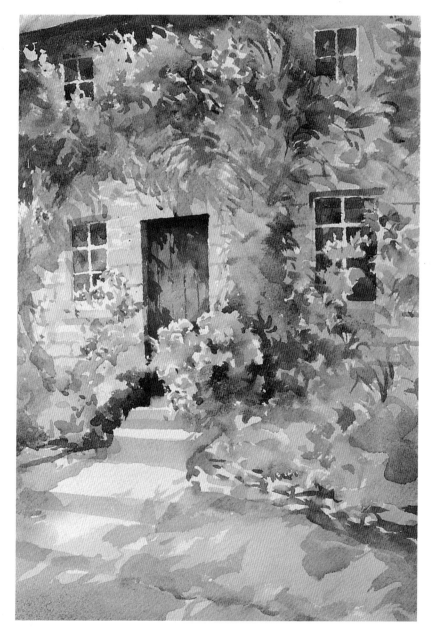

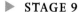

▶ **The Red Cottage Door**
35 x 25 cm (13³⁄₄ x 9³⁄₄ in)

WINNING TIPS

Handling a colour scheme

- Let colours mix on the paper.

- On the palette, stick to two colour mixes rather than three.

- Keep the bead of liquid high on the paper for more transparency, especially in the darks.

- Give tonal values a colour identity.

- Wash your brush out between visiting each colour.

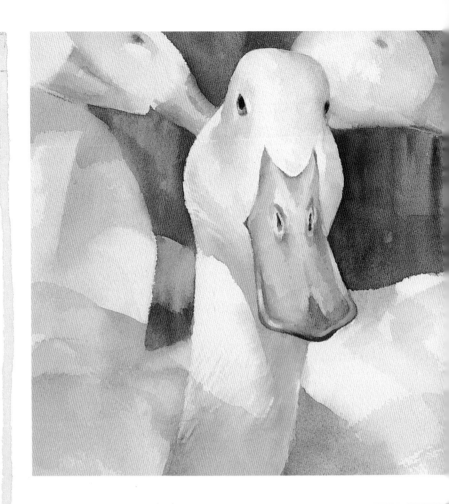

▶ **The Red Carnation**
29 x 48.5 cm (11½ x 19 in)

In this picture the focal point is the red carnation. I strengthened the red and orange near the centre of this flower to emphasize this and kept the darks reasonably cold and neutral, which throws the flowers into relief.

◀ Maynard and Friends
23 x 35.5 cm (9 x 14 in)

This painting uses the primary colours red, yellow and blue. Note the red background, which is a dark foil for the light ducks. Here I've effectively used red, an advancing colour, behind an object. I was able to do this because the red acts as a darker value and therefore goes behind the ducks, which are light.

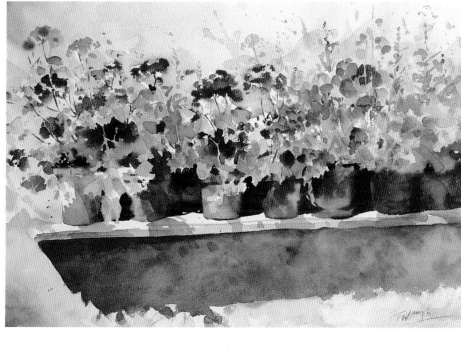

▲ And a Pot of Red Geraniums
29 x 48.5 cm (11½ x 19 in)

While staying in the South of France I noticed how intense the colours were, particularly in the shadows. Here I've used stabs of Coerulem, Burnt Sienna and purple mixed from French Ultramarine and Rose Madder Genuine to intensify the shadow under the shelf. A touch of Cadmium Orange draws the eye to the main flower.

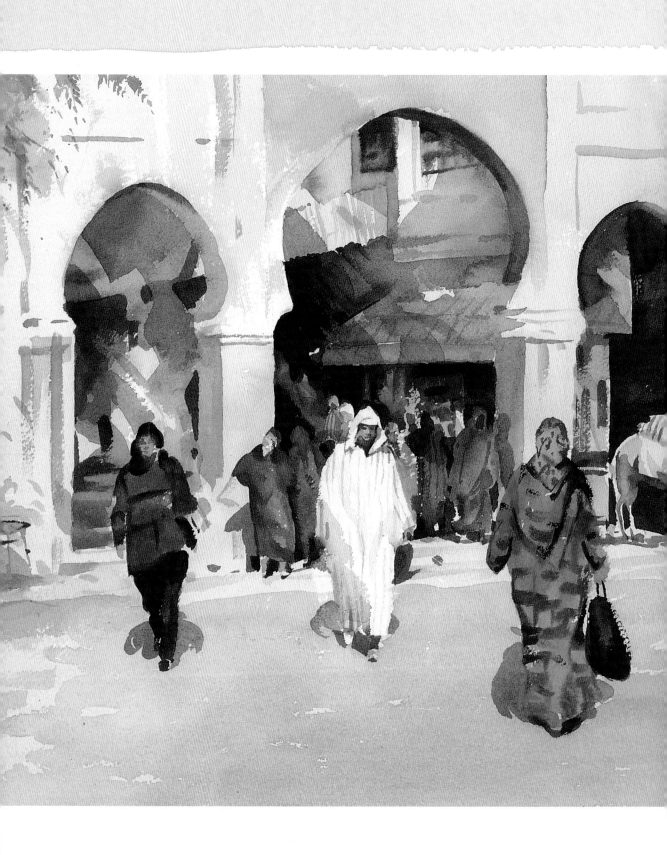

Adding the Furniture

Strong and bold compositions represent a powerful tool for the painter. Some of the best watercolours I have seen are a harmonious arrangement of light and dark shapes over the surface of the paper, with well-thought-out colour relationships, clear focal points and a sense of depth. While technique sometimes serves to please the eye, there is nothing quite like a well-planned composition to create structure in a painting. If you regard your painting as a room, 'adding the furniture' refers to the contents: the placement of the subject matter, tonal values and colour. Getting these elements of design right is a key factor in making winning watercolours.

Planning your composition

Areas of mass shape and how they interlock with one another, including large, medium and small shapes, are important. A small tonal or thumbnail sketch before a painting often gives a fresh insight; it is a reminder of where the key elements are and it also helps you to avoid getting bogged down with detail at this early stage. Where you lead the eye is critical. If you take the viewer to a point in a picture and then leave them with nothing to look at it is disappointing, so forward planning is essential.

◄ Gateway of Fez
30.5 x 48.5 cm (12 x 19 in)

There is a mass area in the foreground which the figures overlap, and they also interlock with the three arches. All the figures are dark except the focal figure, which is light. His placement stimulates the eye and keeps it held in the painting.

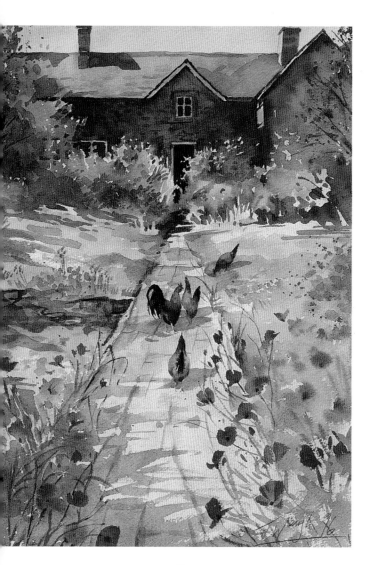

Compositional devices

There are various ways of composing pictures, including some tried and trusted devices which I consider particularly beneficial. These are T-shaped, triangular, diagonal and bookend compositions. The subject matter in your painting can be arranged around these underlying structures to give the picture a solid and stable appearance as well as giving you more confidence in the execution of the work. Spending 10–20 minutes in thought about this before you start to paint will pay dividends later. In the beginning stages a good maxim is: 'Think more, paint less.' Making a few small thumbnail sketches to work out compositional relationships such as mass areas of lights and darks and the placement of the focal point is useful.

◀ **Springfield Cottage**
35.5 x 25.5 cm (14 x 10 in)

In this portrait format the cottage forms the bar of a T, with the path leading the eye to the doorway. The chickens provide interest and movement along the way. The sunlit and shadowed areas bring a subtlety to this otherwise bold composition.

▶ **Cat and Nasturtiums**
23 x 23 cm (9 x 9 in)

In this square format the cat's face is placed at the apex of an unseen triangle, the base of which is at the bottom corners of the painting. The background is divided by the post, which creates compositional interest. Because the post is blue – a receding colour – it helps to give a sense of depth in the painting.

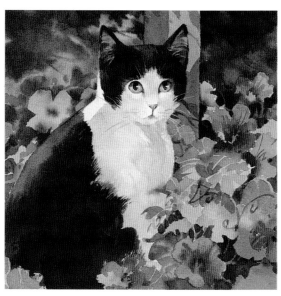

▶ Hanging Roses
61 x 51 cm (24 x 20 in)

A simple diagonal composition can be very effective, providing a dynamic look to the painting. There is also energy in the contrast between the hard shapes of the roses themselves and the soft background.

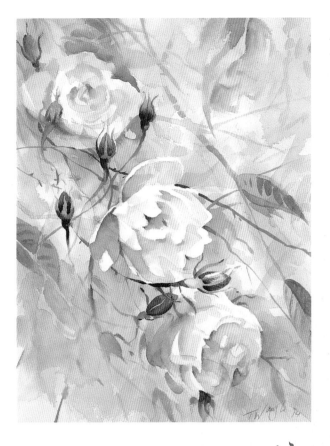

▼ Berkshire Pig
29 x 48.5 cm (11½ x 19 in)

The face of the pig is an unusual and interesting assembly of light and dark shapes, focusing on the snout. The light brick wall to the left and the dark fence to the right create bookends to hold the viewer in the pen. Sometimes a bookend composition can be referred to as a framing device.

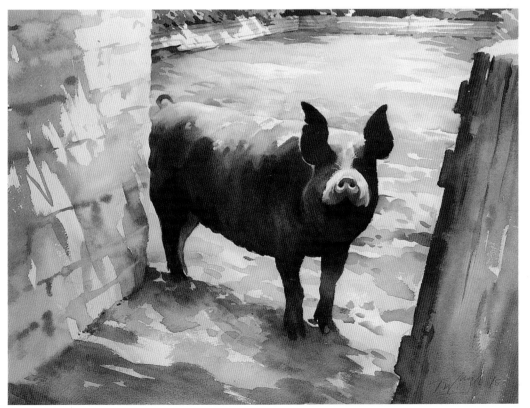

The focal point

The focal point is the area of interest in a painting that first draws the viewer's eye. I like to place my focal point at an unequal distance from all four sides, never locating it right in the middle of a painting as this can make for a very uninteresting composition. My aim is to give the viewer an opportunity to engage with my paintings, and being creative with the placing of the focal point encourages participation. Don't avoid having empty spaces in pictures as they are often valuable to the point of interest by giving a sense of balance with the more detailed or focal areas.

Focal points can be the whole or just part of a subject. Sometimes using a different colour or

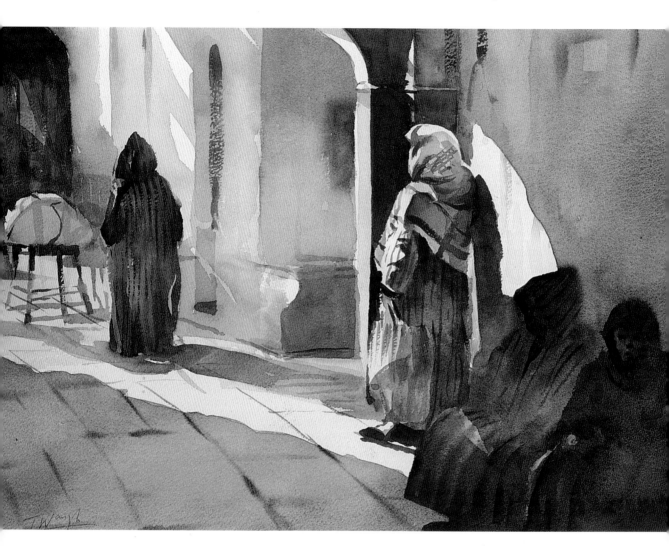

▲ **Sunlit Medina**
29 x 48.5 cm (11 ½ x 19 in)

In this painting the woman's headscarf is the focal point and it is trapped into place by a configuration of lights and darks around it. The warm red colour emphasizes the focal point because it is local only to this part of the painting.

drawing the eye to the unusual can be effective. For example, in a field of poppies the single daffodil is king; in a line of upright soldiers, the one scratching his ear will draw attention. In a painting of one large flower, the centre of that flower can be regarded as the focal point.

Focal points can be fun as well as formal. You will find that you will be able to draw attention to the most unusual things by an understanding of how focal points can be utilized; they give a picture meaning and a sense of direction, and are a way of communicating 'Look at this!' to the viewer.

Variety

Variety is the spice of life in painting. Live dangerously and your paintings will be full of interest and your subject matter will be transformed into poetry. Shapes provide a stimulus for this poetry, For instance, if your painting contains one or two large shapes of similar size, include medium and small shapes as well. I call this the 'Daddy, Mummy, Baby' principle. Large areas of open space can be balanced with busier areas of interest, another way of creating variety.

Well-constructed paintings contain variety not only in shapes but also in tonal values and colours. Large areas of half-tone can be boring to the viewer, but a few well-placed dark accents on them can restore the dynamics.

We often read a subject by its edges and how those edges are described can provide a golden opportunity to include variety. Practise painting edges as hard, soft or broken to maximize this.

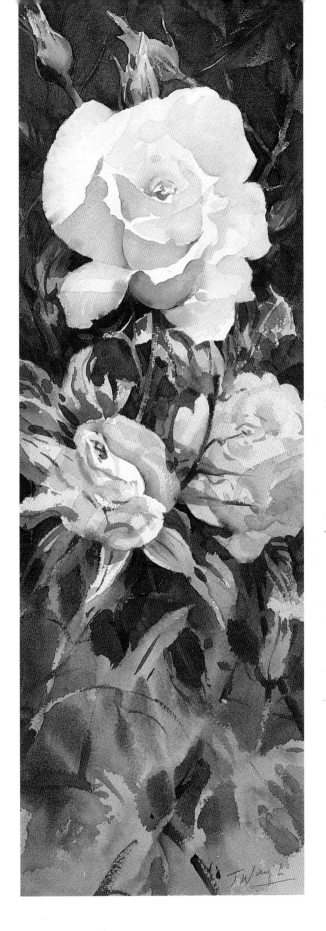

▶ **Long White Rose**
48.5 x 16.5 cm (19 x 6½ in)

A large rose, a medium rose and a bud represent the 'Daddy, Mummy, Baby' principle of variety in shapes. The dark background contrasted with the light roses provides variety in tone, while the crisp edges of the petals on the main rose are balanced by soft edges on the foliage.

Balance

Be careful not to over-elaborate on your basic composition, as this can often lead to a sense of imbalance. Painting too many bricks in a wall can make the wall over-fussy, for example. It is important to be selective, as this leads to a mature and uncluttered work. Sometimes it is not so much what you select in as what you select out that counts. Showing the overall shape and size of objects is preferable to any pattern or detail at the initial stages, and if you block in the main areas first until the whole paper is covered you are more likely to achieve balance. Relative proportions come into their own here, so a keen eye for measurement needs to be cultivated.

Balance can be symmetrical or asymmetrical, but whichever it may be it is the interplay between colour, contrast and sizes of shapes that is the key to creating it. There should be an evenness of touch in your painting, with nothing overworked or too detailed; rely on the placement values of your composition for a successful picture.

If you're in one area for more than two minutes in a watercolour painting, get out and stay out until the paint has dried in that area. That way all aspects of your painting will receive equal attention. Don't get bogged down in one small area, but instead keep thinking about the painting as a whole; you can always go back if needed.

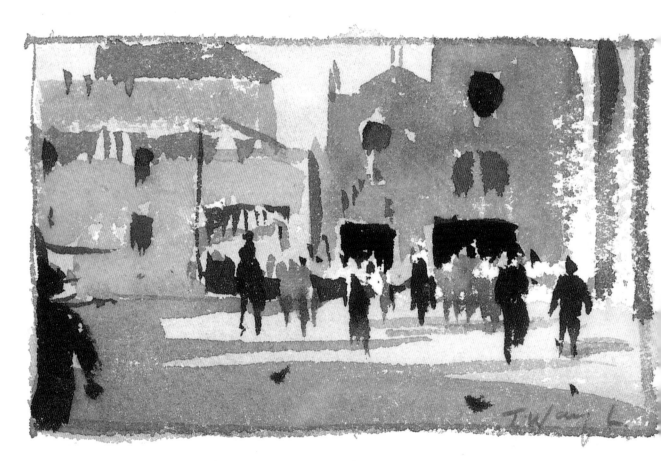

▲ In this compositional sketch of a complex scene of the Frari in Venice I used red, yellow and blue and mapped out the mass areas of buildings and shadow to create a balanced composition. Notice the distribution of dark values across the sketch in a variety of shapes.

▲ This simple watercolour sketch shows how a sense of balance can be created by using warm and cool colours which also help to produce a sense of depth.

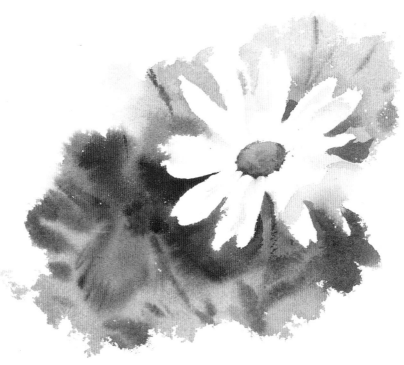

▶ The crisp white petals of the daisy contrast with the soft edges of the darker poppy, creating a simple balance of hard and soft together with light and dark.

Demonstration Still Life

Organizing a composition

MATERIALS

Brushes Round brushes No. 14 sable, No. 8 Diana Kolinsky sable and No. 5 sable

Colours Alizarin Green, Burnt Sienna, Cadmium Orange, Cadmium Red, Cadmium Yellow, Cobalt Green, Cobalt Violet, Coeruleum, Crimson Alizarin, French Ultramarine, Indian Yellow, Lemon Yellow, Naples Yellow, Rose Madder Genuine

Paper Whatman 400 gsm (200 lb) Rough

Other items Daler-Rowney BB9 palette; lightweight board; 5 cm (2 in) masking tape; 2 water jars

▲ **STAGE 1**
I started this still life with a pale wash of cool and warm colours, working across the paper from top left to bottom right with my large brush. The warm colours established what would later be the warm whites of the picture. I left it to dry thoroughly, then started to paint the leaves on the left, using a variety of greens that I allowed to mix on the paper.

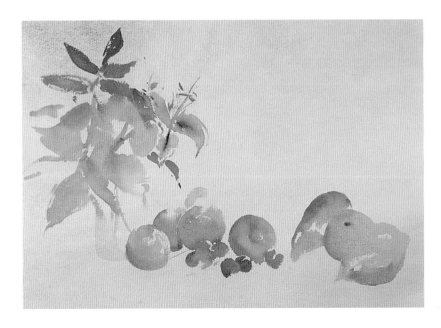

◄ **STAGE 2**
I used the whole of the brush to paint the basic shape of the apples, then blocked in all the main areas of the fruit with Rose Madder Genuine for the red apples; Aureolin and Coeruleum for the green apple; Yellow Ochre and Coeruleum for the pears; and Crimson Alizarin and Cobalt Violet for a few cherries.

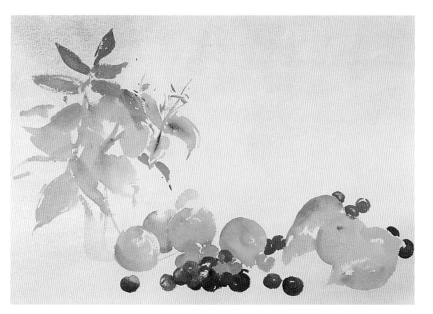

STAGE 3

I painted in the rest of the cherries using a variety of cold reds and blues. Although cherries are similar to each other in colour I like to explore the variety of shades within them.

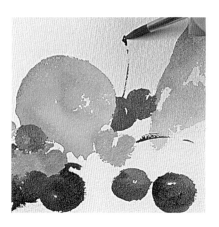

STAGE 4

Using a half-loaded No. 8 brush I painted in the cherry stalks with Burnt Sienna and Alizarin Green, taking care to wash my brush out in between the application of each colour.

▶ STAGE 5

After painting in the cherry stalks I concentrated on the forms of the individual fruits and all the little dents and markings. I put a wash of Yellow Ochre over the pear and used Alizarin Green and Burnt Sienna wet-into-wet for the apple on the right. This dark green had the effect of throwing the lemon forward, and I used simple tick shapes with the brush to articulate a few of its recessed areas. Next I painted a dark purple under the central apple, caused by the reflected colour from the cherries.

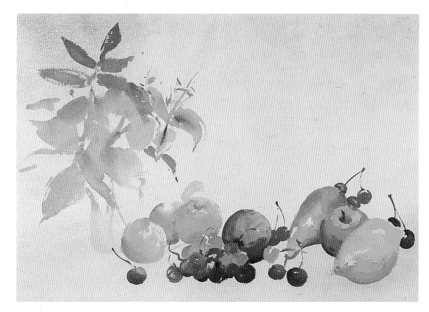

▶ STAGE 6

I returned to the apples, using Alizarin Green and Burnt Sienna for the darker green in both green apples. I mixed Alizarin Green with Aureolin for the lighter green parts and added a drop of Cadmium Red to capture the bloom. Next I mixed Burnt Sienna with Crimson Alizarin to make a dark red for the red apple on the left. Studying the glass jar, I started to paint the greens in it using Naples Yellow and Coeruleum. Indian Yellow and French Ultramarine made a dark, warm green for the leaves.

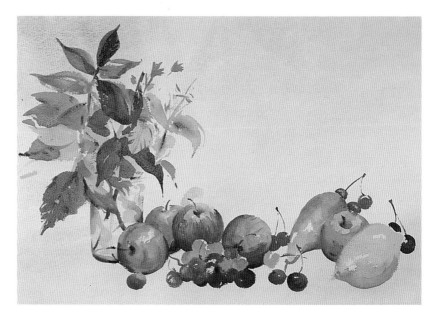

◀ STAGE 7

Next I painted in the dark centre of the lily, using a mix of Cobalt Violet and Crimson Alizarin applied with a No. 8 brush and simple brushstrokes.

◀ STAGE 8

I painted in the rest of the lily, using Cobalt Violet to enhance the pinks. The pear behind the apples was painted in using simple brushstrokes, pull for shape and push for line. I added a few cherries to create more interest in the composition and outline.

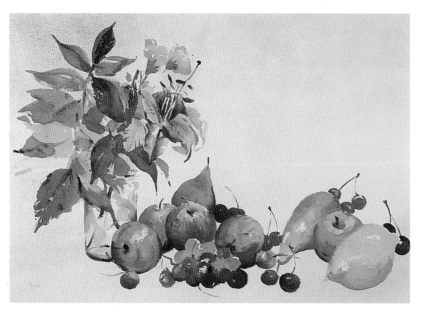

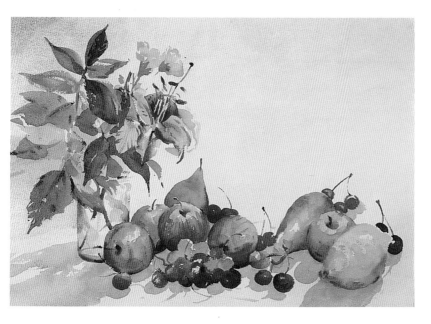

◀ STAGE 9

To paint the shadow of the jar and fruit, particularly across the edge of the apple and across the front of the picture, I used French Ultramarine and Rose Madder Genuine; I also brushed a little Cobalt Violet into the shadows. The colour of the cherries reflects into the French Ultramarine around them, while the shadow around the lemon has a little Cadmium Yellow dropped in. I also used a little dry brush technique over the lemon to indicate texture.

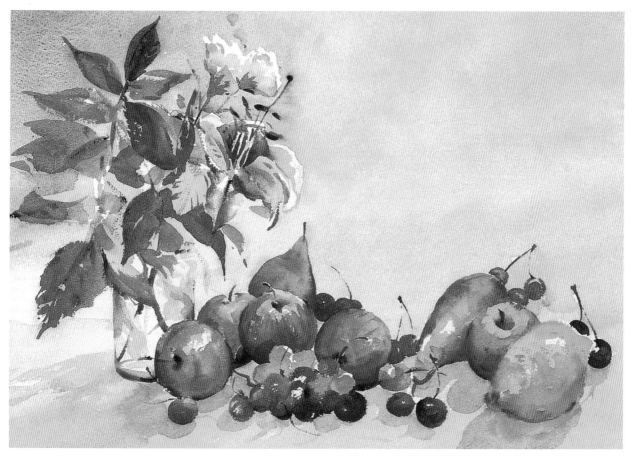

Still Life with Fruit and Flowers *35 x 50 cm (13³/₄ x 19³/₄ in)*

▲ STAGE 10

Finally, I placed a large graded wash of French Ultramarine over the background of the picture. This helped the flowers to come forward and also brought some atmosphere into the background.

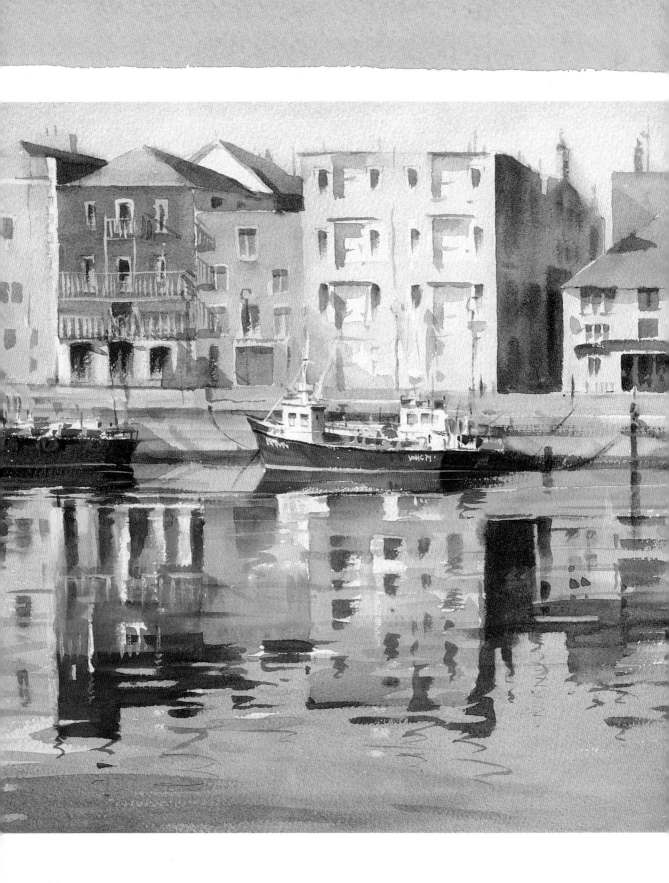

Shadows and Reflections

When I begin a painting one of the first things I think about is light and shadow, particularly when the subject is water and reflections. Painting water is exciting as it is constantly in motion, abstracting the forms above and around it. I use dots, dashes and slabs of colour to portray this. Shapes appearing above the waterline are usually echoed on the surface of the water as reflections. One way of differentiating the reality from the reflection is to paint with vertical strokes above the waterline and horizontal strokes below it. Interesting visual effects start to happen between the light and dark areas of the painting and I tend to sacrifice accuracy for impression in such cases, as this is where I feel the poetry lies.

Reflected light

In representational painting shadows are an integral part of the picture, and reflections are all around us. In nature there are both matt and shiny surfaces, and being able to depict these convincingly is an important weapon in the artist's armoury. Observing reflected light and colour even in shadow areas will increase your perception of the scene and add subtlety to your painting.

◀ **The Red Boat, Plymouth**
29 x 48.5 cm (11½ x 19 in)

This painting divides into two halves, with the sky, buildings and boats above the waterline and their reflections below. Notice how the tops of the reflected buildings are broken up by the horizontal movement of the water. Generally I have used vertical strokes to paint above the waterline and horizontal ones below.

Counterchange and negative spaces

Counterchange is the principle of light against dark and dark against light. A tree can appear as a silhouette against a skyline but be lighter against the landscape beneath, for example. A white daisy with shadows across it can also have a light and a dark side. Effectively, painting only the shadows and negative spaces around a daisy will give you the flower shape for free!

Concentrating on painting in counterchange forces you to pay attention to the things you are not

▲ In this sketch only the recessed areas, or spaces in between, and their reflections have been painted, creating a patterned appearance.

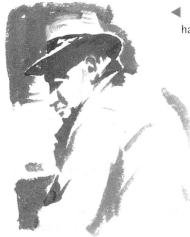

◀ Here only the shadow areas have been painted, using one tone. This limited selection against the white of the paper creates the illusion of the subject.

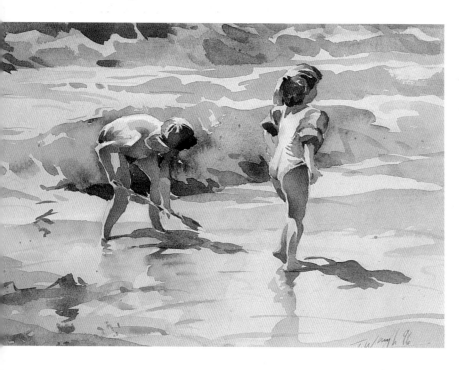

◀ **Spades and Armbands**
23 x 35.5 cm (9 x 14 in)

The lights and darks of the figures and their reflections interlock with the rocks and the sand. The sunlight on the children is trapped against the dark rocks behind them, while their legs appear dark against the sand.

painting – in other words, the spaces you leave behind. Remember that shadows are shapes too, and they often traverse both the subject and its surroundings. I find that tying the subject and its shadow together simplifies matters.

Reflections

I enjoy the way reflections abstract forms because this gives me a greater chance to interpret them freely. The way water sometimes distorts the form it is reflecting into meaningless blobs is very exciting;

▲ In this detail of reflections beneath a bridge in Venice you can see that the horizontal brushstrokes below the waterline and the vertical ones above it help to make a visual distinction between the two areas of the painting.

even the most rigid structure, such as a building, can become quite amorphous.

When you are painting reflections, bear in mind that you are describing an effect. Water is an ever-changing substance and focusing in on the effect is more important than trying to paint the detail. Capturing the moment the water moves is paramount to that effect, as that is when the shapes break up and compress.

Depending on the available light, colours can be either intensified or diffused when reflected. The sparkle on water that is created when sunlight hits it can be achieved by using the dry brush technique.

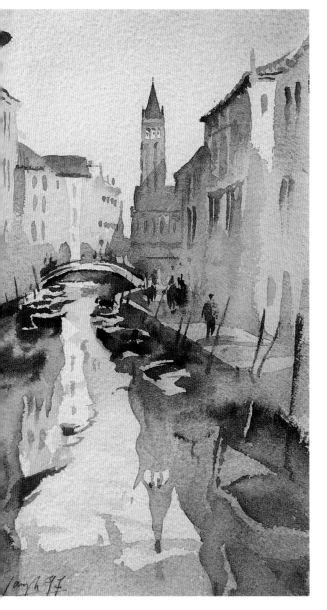

◄ **Liquid Reflections**
26.5 x 18 cm (10½ x 7 in)

Notice the way that in this painting of Venice the reflections of the buildings start to break up into amorphous shapes. The lower parts of the boats, together with their shadows, blur into their reflections.

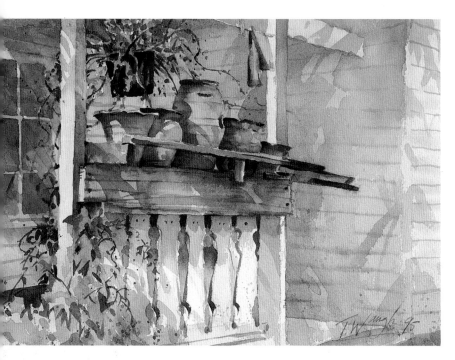

The pots on the porch get their
roundness from the use of shadows
and reflected light. The various colours
used to describe the pots and their
surroundings are reflected in the
shadows over the white porchway.
Note the hints of warmer colours in
the shadow areas.

Reflected light

Most objects show some reflected light, meaning the
light and colour that bounce off other objects
nearby. It can be an illuminating factor in shadows
and is invaluable in helping to create a sense of
volume. This effect is more easily seen in strong light
conditions, but it is also present in softer or diffused
light. Remember that reflected light is never as
strong in the shadow areas as it is where the light
hits an object directly; you will upset the balance of
your light areas if you are not careful.

When you are looking at an object or shadow that
contains reflected light, half-close your eyes as this
will help you to see the tonal changes and thus to
understand the distribution of light. Reflected light
also brings colour with it; you probably remember
the childhood game of holding a buttercup under
your chin to turn your skin yellow.

▶ Afternoon Tea
30.5 x 30.5 cm (12 x 12 in)

There is plenty of reflected light and shadow in this painting,
including the metallic surface of the silver teapot and jug,
and the glass vase. The cool shadows of afternoon contain
blues, purples and browns. The backlighting allowed me a
chance to explore these subtleties because the light became
diffused around the objects as it illuminated the side that
faced away from me.

► **Rhianna**
35.5 x 25.5 cm (14 x 10 in)

This is a painting of my daughter, Rhianna. The shadows on the flesh tones contain a variety of reflected colours, as do the shadows on the paving stones and foliage behind.

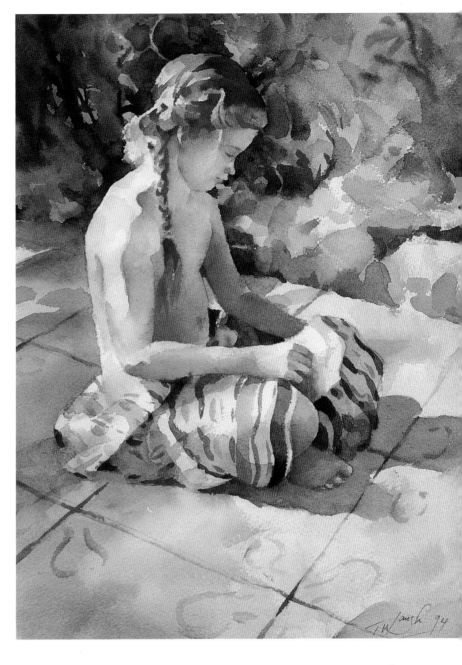

Temperature and colour

When you are exploring shadows in paintings it is useful to see yourself as a thermometer, gauging the temperature and colour. In cool shadows you will often notice a warmer glow of colour, and on closer study you may begin to discern an array of subtle colours that enrich the depth of the shadow. Spend five minutes focusing on a large shadow area and you will be amazed at the rich coloration that is

within it. An otherwise seemingly grey stretch of road can seem in late afternoon sunlight to be streaked with shadows that are positively purple, or even orange, for example.

Learning to tune your eye in to shadows trains your colour sense; by using yourself as a thermometer, asking yourself 'Is it cold? Is it hot?', you will notice hot spots in cool areas and vice versa. Translating this into paint will help to bring a real sense of colour and light to your pictures.

Trapping the light

The effect of light in watercolour is a subject unto itself. Creating the effect of the light patterns in a painting can alter your perception of the subject matter, and an ordinary everyday subject seen under certain lighting conditions can be transformed into something extraordinary. For example, the patterns created by dappled light under a tree, or the sparkle of sunlight on water, give you a chance to paint the light itself rather than the subject. If you pay attention to what the light is doing on your subject and paint those effects, it will be reflected in the end result.

The medium of watercolour is well suited to trapping the light. Generally, watercolours start with a piece of white paper and by means of successive washes become darker, so trapping the effect of light needs to be thought about right at the beginning of a painting. In the painting of the medina shown below, the trapped light on the figure takes on a certain shape and was left unpainted right from the off as it was what inspired me to paint the scene. In a picture I concentrate on the shape of the spaces that are being left out, or not painted.

▶ In this illustration there are two major areas of light captured: the light on the back of the gondola, and the light area in between the post and the gondola. I used one flat tone wash.

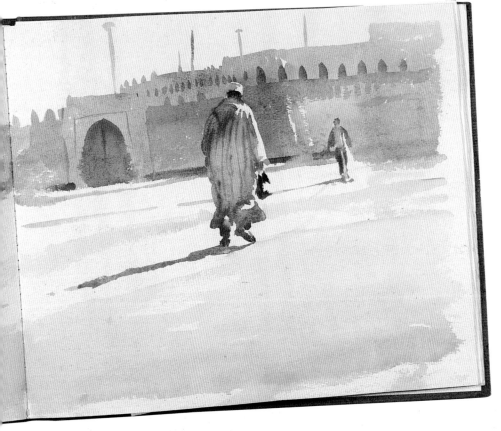

◀ While I was studying the effects of morning light in Morocco I saw figures coming and going from this medina. I trapped the light using a six-colour palette, but the principles are the same as in a flat tone wash.

Shadows

It is possible to paint a subject using entirely areas of shadow, painting the way they interlock with the light. Objects outside your picture space also cast shadows into it. In other words, you can paint the effect of dappled light under a tree without painting the tree itself. Shadows are an indication of time of day, the long shadows of early morning or late afternoon being evocative of the moment. I consider shadows to be subject matter in themselves and take delight in painting them and their effects.

Shadows can be glazed over subjects once these are dry, using transparent washes. Remember that shadows are like ghosts – you can see through them, and the medium of watercolour lends itself to this because of its transparency. A watercolour in which you are able to see subject matter through the shadows in this way can be very special.

▶ In this sketch I laid an initial variegated pale wash and then painted the shadow areas only. All the light areas were left showing the original wash, creating the effect of sunlight.

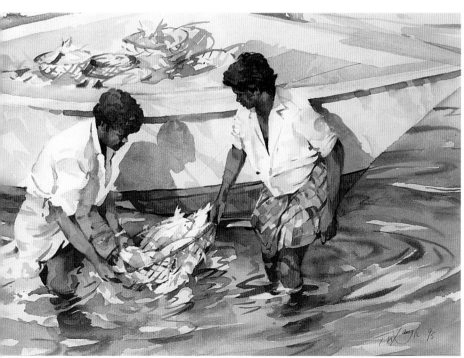

◀ **Washing the Fish**
29 x 48.5 cm
(11½ x 19 in)

The shadows cast by the two figures show a variety of colours, including several blues and greens, over the surface of the boat. The shadows throw the figures into relief and give a sense of depth. Notice that reflections from the water also throw shadows onto the boat.

Demonstration Venetian Canal

Painting light and reflections

MATERIALS

Brushes Round brushes No. 14
sable, No. 8 Diana Kolinsky
sable and No. 5 sable.

Colours Burnt Umber, Cadmium
Orange, Cobalt Blue, Coeruleum,
French Ultramarine, Naples
Yellow, Raw Sienna, Rose Madder
Genuine

Paper Whatman 400 gsm
(200 lb) Rough

Other items Daler-Rowney
Educational Stacking Palette BB9;
lightweight board; 5 cm (2 in)
brown paper masking tape;
2 large water jars

▲ **STAGE 1**

Venice is one of my favourite places to paint; the light and colour are splendid and the former has the effect of dissipating the forms around the buildings, bridges and boats. Using a No. 14 brush, I started this painting of a backstreet canal with a multicoloured wash from Naples Yellow, Raw Sienna, Coeruleum, Cobalt Blue, Cadmium Orange and Rose Madder Genuine. Raw Sienna is particularly useful for the buildings in Venice because it has a sandy quality in the colour. I left some white areas for the light rather than covering the entire surface of the paper. Although this wash was very pale I established the composition roughly right from the start, painting in the mass areas of the buildings and where the painting divides above and below. I let the wash dry thoroughly before moving on to the next stage.

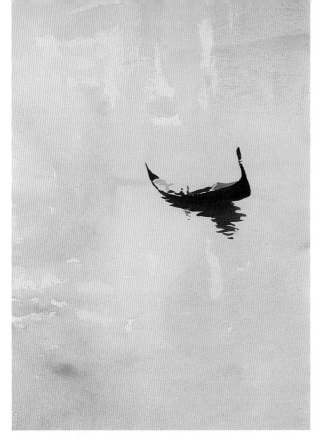

Using my No. 8 brush and a dark mix made from Burnt Umber and French Ultramarine, I painted the gondola and some of its reflection, where I added a touch of Cobalt Blue to make it cooler. The gondola is the focal point for the painting, and I established it by painting it in silhouette. I made a single stroke of Cobalt Blue to articulate the top edge, being careful to leave out the areas where the light is striking it.

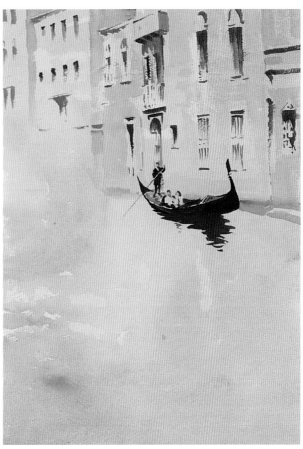

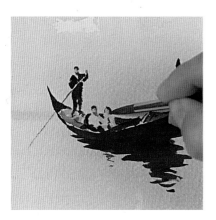

▲ STAGE 3

Using negative painting and a No. 5 brush, I painted in the people and the gondolier, using the tip of the brush and a simple shape to suggest the hair.

▲ STAGE 4

I established the windows and doors of the building behind the gondola using negative painting and single brushstrokes with a No. 8 brush. I laid a wash of Cadmium Orange on the buildings and used Raw Sienna to show the division between the ones in the centre, then Cadmium Orange for the same purpose on the left. Next I added a little Rose Madder Genuine for the building in the middle distance and a wash of Naples Yellow along the base of the buildings.

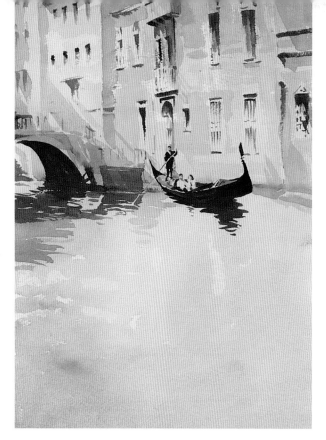

STAGE 5

I painted the bridge using Burnt Umber and Rose Madder Genuine, mixed in the palette. I employed Cobalt Blue and Burnt Umber for the underside of the bridge and its reflections, taking care to leave out the gondolier's paddle. For the shadows on the buildings I used the transparent colours French Ultramarine and Rose Madder Genuine. The shadows and their reflections tie together and I painted them at the same time.

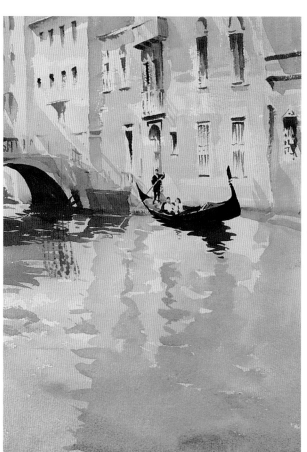

STAGE 6

Next I brushed in the pale wash reflections of the buildings with my large brush, using Rose Madder Genuine with a touch of Cadmium Orange.

STAGE 7

The next step was to expand the pale reflections of the buildings right across the water. I dropped them all in wet-into-wet, using mixes of Rose Madder Genuine with Cadmium Orange and Rose Madder Genuine with French Ultramarine.

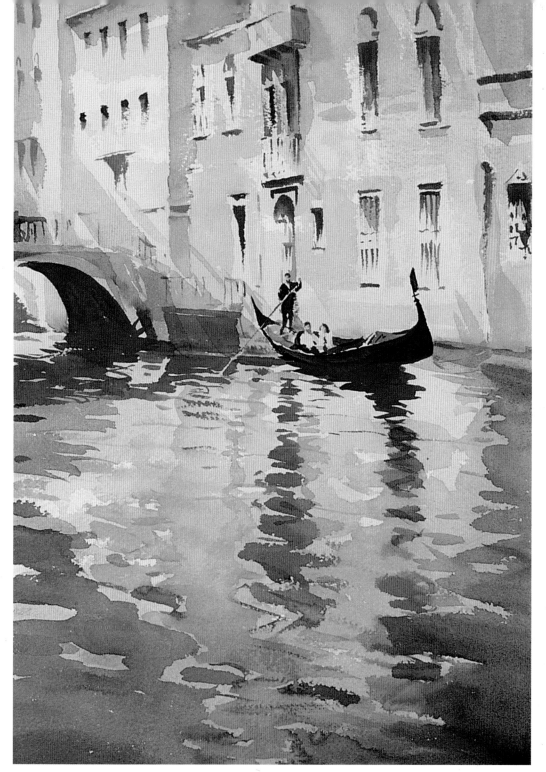

Reflections in a Venetian Canal *35 x 25 cm (13³/₄ x 9³/₄ in)*

▲ STAGE 8

The final stage of the painting was to put in the dark reflections of the bridge, buildings and gondola in the water. For these I used two different mixes: Coeruleum and Cadmium Orange, and Burnt Umber, French Ultramarine and Cobalt Blue. I varied the mixes in order to alter their warmth, keeping the warmer colours to the foreground of the picture and the cooler ones to the middle ground to help give a sense of depth.

Shadows and reflections

- Use counter-change to allow your light and dark areas to interlock.

- For reflections, try vertical strokes above the waterline and horizontal ones below.

- Find reflected light in solid objects and shadows.

- Make trapping the light your first consideration.

- Shadows are like ghosts; they are transparent.

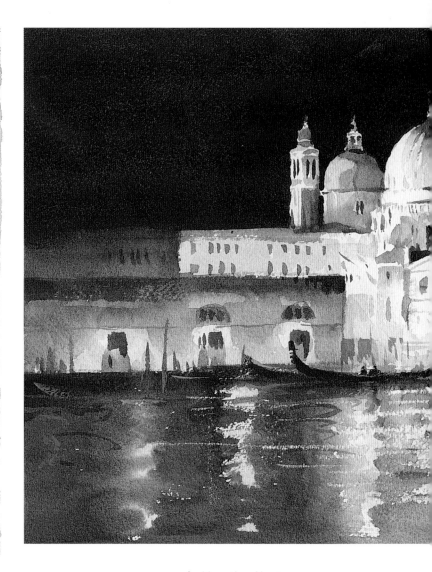

▲ **Venetian Nocturne**
24 x 33 cm (9½ x 13 in)

This is a painting of my favourite building in Venice – Santa Maria della Salute. The colour of the night sky is almost black, but not quite – it consists of Burnt Umber and French Ultramarine over Yellow Ochre and Burnt Sienna. The colour accents for the reflections were done in Coeruleum and Cobalt Blue.

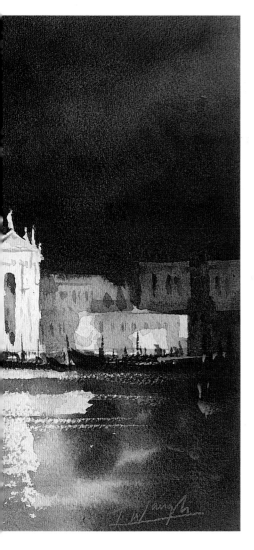

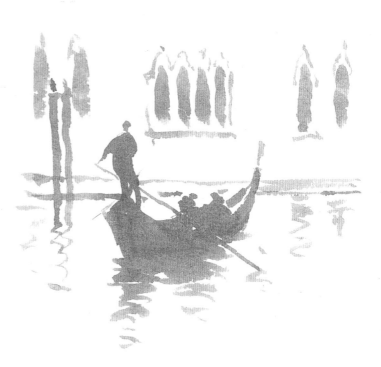

▲ I really enjoy painting watercolour sketches like this one, which was done on the spot while I was in Venice. Note the trapped light on the gondola and the simple negative shapes of the windows, which are reflected in the water.

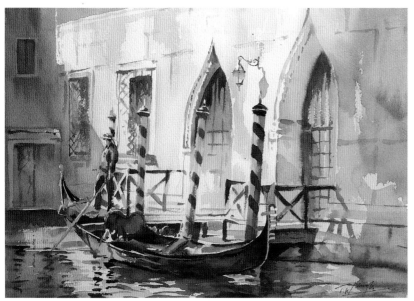

◄ **Gondolier's Respite**
24 x 33 cm (9½ x 13 in)

This gondolier was waiting in a quiet backwater canal in Venice and just as I stopped to watch him the light happened to fall across the scene. The light reflected into the buildings and altered the colours, giving them warmth. I particularly enjoyed the gondolier's red hat band and the stripes on the three poles.

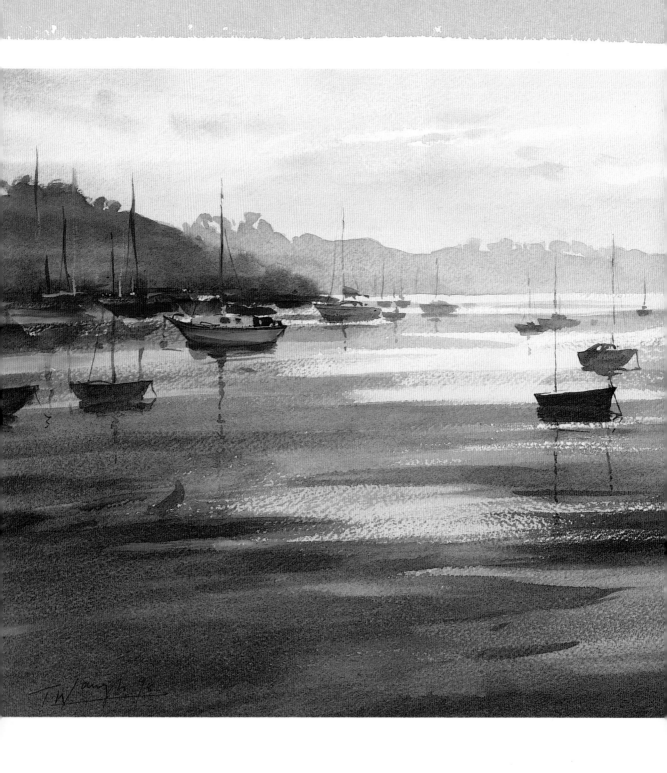

Atmospheric Landscapes

Skies and cloud formations are a well-documented starting point in watercolour painting. Think of the horizon line as a movable axis up and down the picture which allows you to include more or less sky depending on its position. For me, what gives a landscape its interest is how this axis is broken by objects that interlock between sky and land.

In a landscape painting the artist and the viewer have to work together. In my opinion, an impressionistic approach to landscape painting creates a dialogue between the painting and the viewer. This chapter looks at how aerial perspective and other atmospheric effects can help this dialogue.

Creating balance

The harmony of the whole painting is worth more than the specific parts. When looking at a landscape, try to consider how the sky, time of day and weather conditions create an overall mood, then select from the information in front of you to keep a sense of balance and simplicity.

◀ **Dawn, Helford Estuary**
29 x 48.5 cm (11½ x 19 in)

After painting the sky in pale tones I established the horizon line by putting in the mass areas of headland. The rest of this painting is concerned with water and space. The masts of the boats break the skyline, which helps to provide interest in the painting. Note the dry brush technique used on the water to create sparkle.

Atmosphere and aerial perspective

Discussing atmosphere in landscape painting includes looking at both the physical effects of the air around our planet and the feelings that they induce. The type of sky you use in a landscape creates a stage setting for atmosphere in both senses of the word. Cloud formations are significant and the colours you use can create a general atmosphere ranging from stormy to calm and all the variations in between. The dissipation of form in the background, on the other hand, is a physical atmospheric effect; an example of this would be a tree-lined avenue where the trees are more clearly seen in the foreground and gradually become less distinct as they recede.

If you look at a landscape you will notice that objects in the distance appear bluer; generally warm colours advance and cool colours recede and when this principle is applied to painting it is known as aerial perspective. In painting landscapes, creating a sense of depth is a primary consideration and aerial perspective is very useful in helping to achieve this. In painting a poppy field, for example, I would tend to use warm reds in the foreground and make them gradually cooler as they move towards the horizon.

Knowing how to neutralize colours in a painting can also be an important tool for toning down their intensity; this can be done by either adding neutral tint or mixing in a small amount of another colour, in the case of the red poppies a touch of Coeruleum.

▼ **Linseed Fields Over Great Barrington**
29 x 48.5 cm (11½ x 19 in)

In this simple landscape the colder colours are reserved for the middle distance and background while the warmer colours describe the foreground path and shadows. Note that the shapes of the trees are echoed in the clouds, which helps to create a sense of balance.

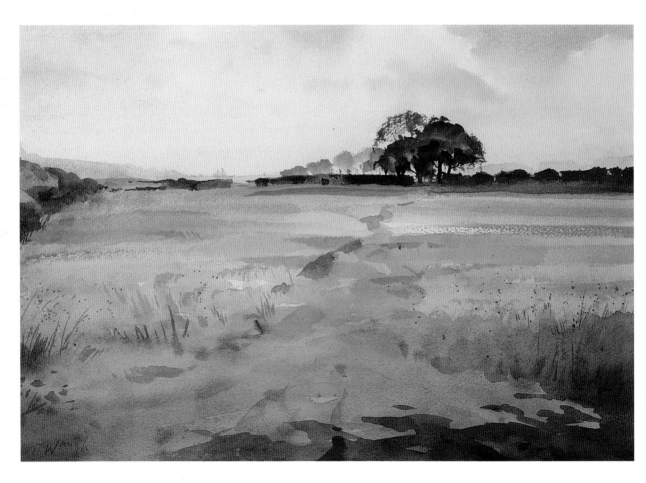

▲ This painting was begun with an initial wash where the colours of the sky and the land were allowed to mix together on the paper wet-into-wet. The grey clouds were dropped into the existing wash wet-into-wet and only then was the painting allowed to dry.

▲ The sky in this painting was done in two washes, with the dark rain clouds glazed over the initial wash after it had dried thoroughly. This gives a sense of transparency, allowing the viewer to see through the clouds to the colour of the sky from the wash beneath.

Skies

Painting skies is the foundation of landscape painting, and painting the effects of cloud formations extends your skill as a watercolourist. Skies and cloud formations can vary from country to country; think of the Cobalt Blue of a Mediterranean sky or the Coeruleum of the northern hemisphere. There are warm and cool colours in the sky and the quantities of each can suggest a time of day or even a season. I like my skies to create a mood: stormy and dramatic, cloudless and tranquil, bursting with colour or just misty. Sometimes a flat wash of pale blue will suffice. I find my initial sky washes can greatly affect the outcome of my finished landscapes. They provide a key to the overall coloration and mood of a picture.

Clouds in a painting tend to be more amorphous and larger in shape at the top of the picture and become more condensed and linear as they move towards the horizon; this helps with recession, or sense of depth. I have noticed that if I keep my grey clouds soft and my white clouds crisp that it is more descriptive and the interplay between hard and soft edges creates interest. I prefer to keep my skies simple, using only a few cloud formations and/or a few gradations. Practise painting skies as often as you can and you will learn a great deal about the handling of watercolour and also develop a freedom and spontaneity in your work.

▲ **Sunset on Lake Ocoee, Tennessee**
25.5 x 35.5 cm (10 x 14 in)

This scene had to be painted quickly before the light faded. I was inspired by the dramatic effects created by the colours and tones of the sunset where the cloud formations and their amorphous shapes became more stretched towards the mountain tops.

Trees

When you are painting trees in a landscape, block in the mass areas of their form to establish the main shapes before concerning yourself with individual leaves and twigs. Try to find three natural divisions in the foliage of these mass areas, as the silhouette of a tree will indicate its species to the viewer.

Remember that there are negative spaces and areas of trapped light in trees and they play an important role. A simple way of thinking about this is to visualize the trunk and the major branches as a skeleton underneath a drapery of foliage. Winter is obviously a good time to study the skeletons of deciduous trees.

Including trees is a useful device for breaking the skyline in a landscape. They should be regarded as architecture, or a natural structure upon which to build your painting. I often use dry brush technique to form the broken edges of foliage. When trees form clumps and overlap the patterns created can be truly lovely.

▲ Most of this tree is formed by painting the main mass of foliage. Leaving the light holes in it gives greater description of form.

▲ Trees form clumps and, whether in groups or on their own, help to describe foreground, middle distance and background. Generally trees are larger in the foreground and get gradually smaller towards the background.

▲ Here the trees form the architecture, or structure, of the painting, together with the hedges and fences.

▲ This sketch illustrates how the trees stand out against the sky and and become more indistinct below the skyline.

Revealing shapes and edges

The use of silhouette in watercolour painting is a handy way of describing edges and shapes. When you are reducing a shape to its silhouette it is important to pay attention to the form you are creating, and the way you delineate your edges will help to reveal this. Experiment with different types of edges: hard and soft, broken and continuous.

Painting silhouettes is also good training for eliminating unnecessary detail. Tree shapes can always be broken into subdivisions in subsequent washes.

Shapes reveal themselves against the sky but often get lost below it; for instance, trees and buildings in a background can appear as a continuous shape, disclosing their form only where they are outlined starkly against the sky. It is the way that shapes and edges are revealed that is so important in understanding the subject in a picture, both for the painter and the viewer.

▲ Tobogganing on Pool Meadow
25.5 x 35.5 cm (10 x 14 in)

The trees in the top half of the picture describe two different types of edges: soft shapes merging with the sky in the distance and harder, more skeletal shapes in the middle distance.

Demonstration Tennessee River

Painting a landscape

MATERIALS

Brushes Round brushes No. 14
sable, No. 8 Diana Kolinsky sable,
No. 5 sable

Colours Alizarin Green,
Aureolin, Burnt Sienna, Cadmium
Red, Cobalt Blue, Cobalt Violet,
Coeruleum, French Ultramarine,
Naples Yellow, Rose Madder
Genuine, Vermillion (Hue)

Paper Whatman 400 gsm
(200 lb) Rough

Other items Daler-Rowney
Educational Stacking Palette BB9;
lightweight board; 5 cm (2 in)
brown paper masking tape;
2 large water jars

▲ STAGE 1

I started this painting by putting
in the sky. Using my large brush,
I first made cloud shapes on the
paper with clear water. I used
Cobalt Blue and French
Ultramarine at the top of the
painting, laid down in patches
and allowed to merge on the
paper, and Coeruleum at the
horizon. I then dropped in a little
Naples Yellow to the cloud shapes
to create the warm white, with a
blush of Rose Madder Genuine
beneath them. Next I laid a
graded wash of Naples Yellow and
French Ultramarine for the
foreground, taking particular care
where I placed the colours. I let
this wash dry thoroughly.

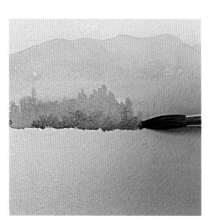

◄ STAGE 2

Using my Daler-Rowney No. 8
Diana brush, I painted the distant
hills with Coeruleum, dropping
in some Naples Yellow to create
some foliage as I went. I also
flooded in some Cobalt Violet on
the foliage in the middle distance.

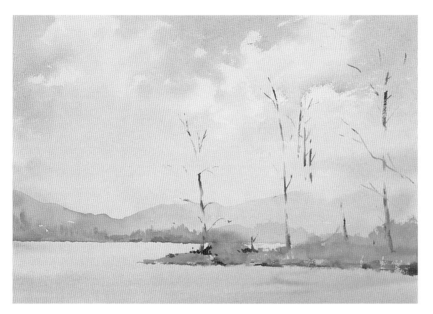

◀ **STAGE 3**

Using Aureolin and Coeruleum and allowing them to mix to a green on the paper, I put in some of the soft foliage and the grasses of the island wet-into-wet. I used a little Cadmium Red to blush in the muddy areas at the waterline. Then, using Burnt Sienna and a little French Ultramarine, I blushed in the skeleton of the tree shapes over the island, with a No. 5 brush. Naples Yellow was useful for the light areas of the trunks and I left spaces where I knew I would be painting foliage.

▶ **STAGE 4**

Using a dry brush, I started putting in the autumn foliage with Aureolin, Burnt Sienna and Cadmium Red, plus Alizarin Green for the leaves that were still green.

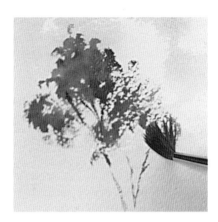

▶ **STAGE 5**

I used lots of lovely greens and reds, picked randomly from my palette, to paint more of the foliage on the central trees. I picked up the different colours in the brush at the same time, without mixing them, and somehow they seemed to retain their separate identity on the paper. This is a riskier method than picking up the colours individually, but it adds variety.

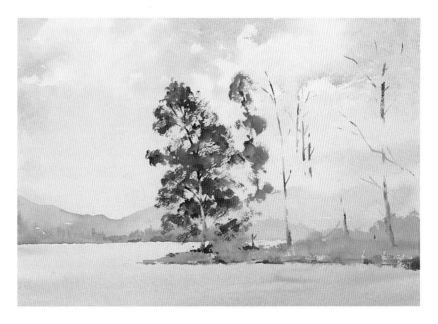

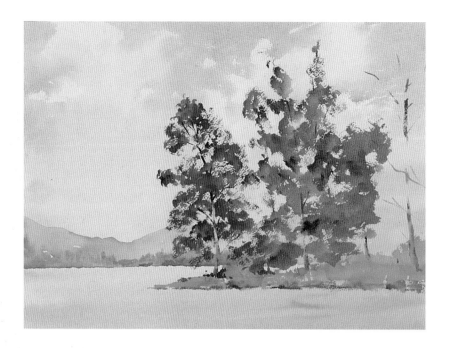

▲ STAGE 6

As I continued with the painting of the trees I used Cadmium Red for the foliage as well as a variety of greens, including Alizarin Green and others mixed from all the combinations of blue and yellow on my palette. I employed some dry brush technique where the trees break the skyline, in order to create broken edges to the foliage.

▶ STAGE 7

Using a No. 8 brush, I finished the block areas of the trees on the right, flooding in some French Ultramarine. I was now working wet-into-wet over a larger area, using a bit of counterchange by leaving out branches from the foliage on the right to give a lighter tone. Next I studied the dark areas of the trees and, using counterchange and with my brush loaded with Cobalt Violet or French Ultramarine, concentrated mainly on the recessed areas and their reflections.

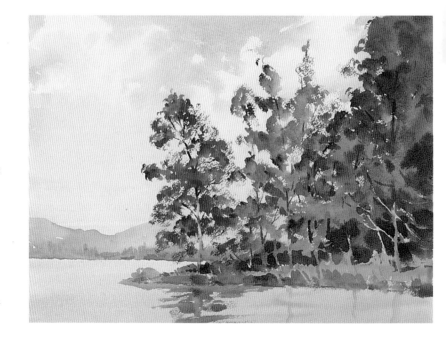

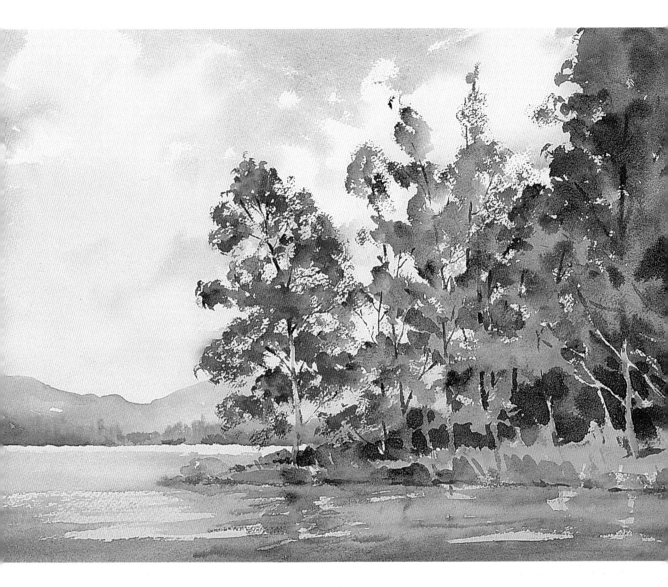

▲ STAGE 8
Reverting to my No. 14 sable, I concentrated on the shadows and reflections in the water. I laid a large wash of French Ultramarine across the bottom, which was dry, and dropped in other colours wet-into-wet to create softness. I added some Cobalt Blue towards the middle distance and added a blush of stronger blue to the mountains on the left to encourage the eye to come in a little more towards the focal tree and to create some balance.
I blushed in a little Vermillion (Hue) over the foliage to bring out the autumn colours and drew in a few details on the branches with a No. 5 brush. The final step was to lay a pale wash of blue in the sky near the central tree to help with the continuity and atmosphere in the picture.

▲ On the Hiwassee River, Tennessee
33 x 48.5 cm (13 x 19 in)

Painting landscapes

- Study cloud formations at every opportunity.

- Always remember to fix your horizon line.

- Use a variety of shapes; nature is not uniform.

- The harmony of the whole is more important than the details.

- Warm colours advance, cool colours recede.

- For atmospheric skies, let your colours mix on the paper.

▶ **Teruel Landscape**
25.5 x 35.5 cm (10 x 14 in)

While I was painting in Spain I noticed how blue the mountains were; in this painting they form a high horizon line. The village is the focal point, captured by a shaft of warm light in the middle distance. The road also encourages the viewer's eye to travel towards the focal point.

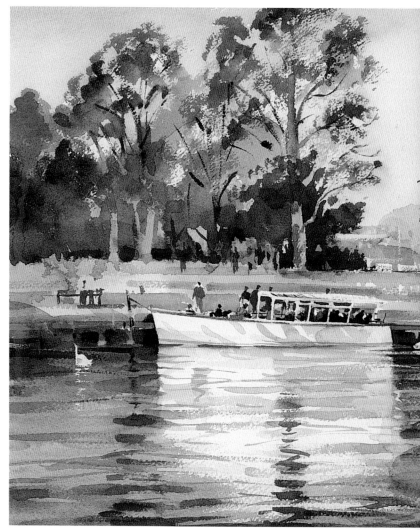

▶ **Pleasure Boat, Stratford-upon-Avon**
29 x 48.5 cm (11½ x 19 in)

Sitting on the banks of the River Avon, I was inspired to paint this scene by the variety of colours and shapes in the trees and how they were reflected in the water, together with the sense of activity created by the pleasure boat. The different tree shapes reveal a variety of edges, including broken, continuous, soft and hard ones.

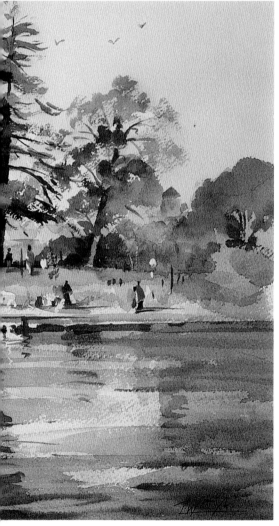

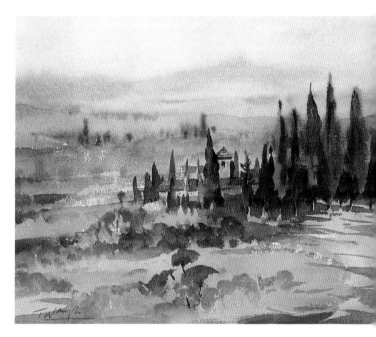

▲ **Tuscan Landscape**
25.5 x 35.5 cm (10 x 14 in)

In this landscape I concentrated on aerial perspective and the dissipation of form caused by atmospheric effects. Note how the cyprus trees break the skyline, effectively tying the middle ground and background together.

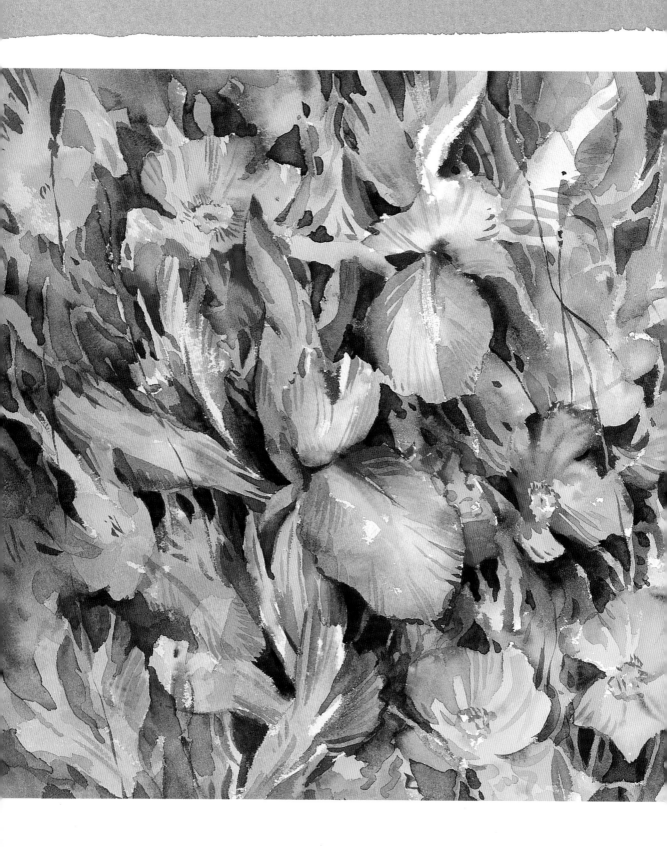

Painting Flowers

Painting flowers in watercolour is an experience not to be missed. It offers you the chance to celebrate colour in its brightest manifestation in nature, and the simple shapes of the majority of blooms lend themselves to free expression. I have learnt a lot about watercolour methods and skills from painting flowers. The way the shadows interplay with the light and colour over flower formations, even in the average garden, is a joy to observe and a challenge to both the beginner and the more experienced watercolourist.

Capturing light and colour

I particularly enjoy painting flowers in their natural setting rather than in formal arrangements in a vase. Although it is important to study flowers and their forms, including the buds, seedheads, foliage and stems, botanical correctness is not my primary concern; light and colour combinations are what I try to express in my floral paintings. In fact flower shapes can be quite abstract, rather than organic, when studied closely. There is nothing more beautiful than a white rose in full bloom bathed in sunlight, and attempting to express that beauty is both challenging and exciting.

◀ **Where the Braver Faeries Climb**
33 x 53.5 cm (13 x 21 in)

This painting takes its title from a line in a poem. I wanted to express the wing-like shapes of the irises climbing through the picture and to explore the relationships between the secondary colours. The abstract shapes seem to fit together like a jigsaw puzzle.

Painting a prima donna

I often paint a single flower, or a prima donna as I call it, larger than life-size. It is better to have a painting of a single flower done well than a group of flowers done poorly. When you are able to paint a single flower well, you will feel more confident about painting groups of flowers and the complexity of the relationships between them.

I always paint my prima donna by working from the centre out, because I find that this enables me to mimic the way the flower actually grows. There is something more organic about this method and it allows you to paint the whole of the flower around its centre.

When I am painting a group of flowers I usually choose just one flower to act as a prima donna so that the focal point is fixed and supported by the other flowers in the picture. In more complex arrangements it is easy to forget details such as this, but composition still needs to be taken into account. This is an opportunity to put into practice the simple compositional rule of placing the focal point at an unequal distance from all four sides of the painting so that it really comes into its own.

Remember that while flowers seen in groups inevitably contain repeated elements, each individual flower varies greatly from the others, and it is these variations that can create interest and excitement in your painting.

▼ Sunlit Rose
25.5 x 35.5 cm (10 x 14 in)

This prima donna rose is painted from the centre out. Notice how some of the background colours merge into the flower at the edges, giving a more natural appearance. The sunlight creates cast shadows that are of equal importance to the form of the flower.

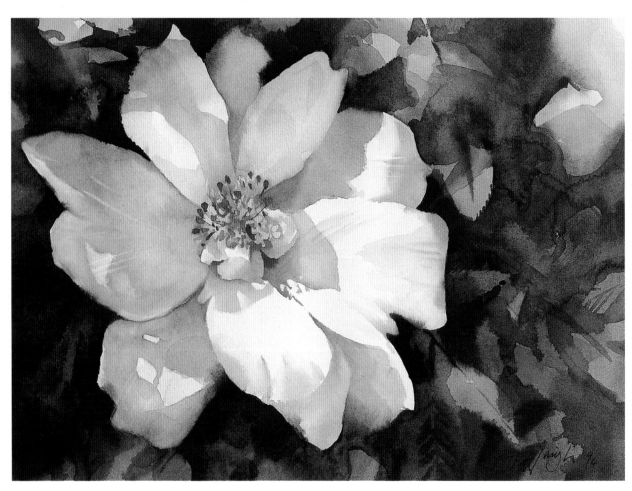

25.5 x 35.5 cm (10 x 14 in)

This painting was an opportunity for a free-and-easy design. The red poppy is king and the rest of the shapes support this with both their colour and simplicity. The dark centres of the poppies were dropped in wet-into-wet.

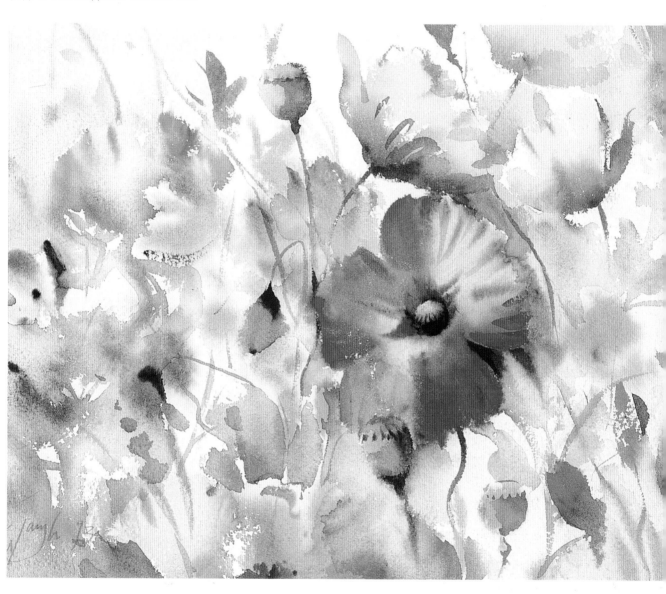

Choosing viewpoints

The form of a flower can change dramatically according to your viewpoint. We tend to view flowers from above, but it can be interesting to look at them from other angles too. The viewpoint that you choose will be very individual to you as an artist.

Generally speaking, the structures of flowers form circular shapes but the viewpoint that you take can affect these shapes. For instance, a daisy seen face on is rather like a wheel, with its centre as the hub and the petals as the spokes. However, when seen in perspective this circular shape becomes elliptical, providing an additional challenge for the artist.

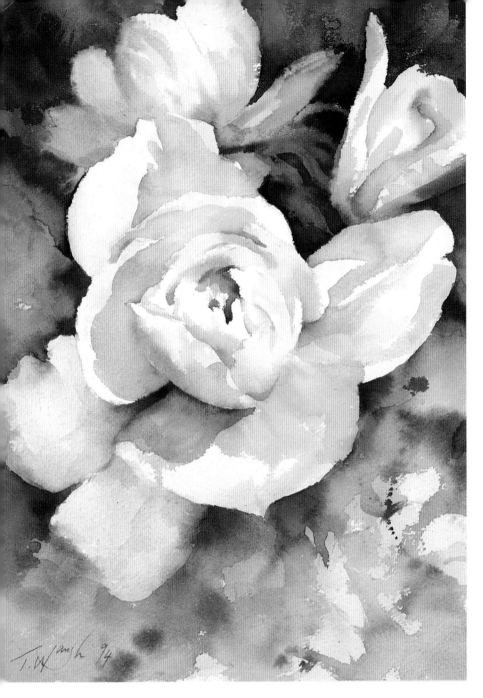

In this painting I wanted to explore all the colour combinations in the creamy soft roses and in the richly coloured background which throws the flowers into relief. The 'Daddy, Mummy, Baby' principle is here illustrated in a floral painting.

Relationships within a floral painting

It is essential to observe the relationships between shapes, sizes and colour, as the combinations of these form the greater part of a flower painting. A good starting point is the 'Daddy, Mummy, Baby' principle (see page 61). Decide on large, medium and smaller flower shapes and overlap and interlock them. You will find that this will mimic the formations found in nature. The foliage is just as

important a factor as the flowers themselves, and can often be a link between one flower and another.

It is as well to bear in mind that your painting may not exactly resemble the arrangement in front of you. Make decisions based on the relationships within your painting; for example, if there is a large area of unresolved space it is possible to add in something from another part of your arrangement to balance your design. Trust your eye and allow yourself freedom of expression.

Flowers in a setting

Flowers brighten up many a drab setting. They spill out from baskets and meander over patios from pot to pot, sometimes resembling colourful jewels in a sea of foliage. Movement and rhythm in these arrangements can seem chaotic at times, and making sense out of the chaos is another step in your decision-making process. It is helpful to find the mass areas of these meanderings and how they join up in your painting. Treat every flower as a blob of paint initially – any detail that is required can be added at a later stage. These blobs of paint will start to make sense as the painting progresses. Try not to focus on any one particular object for too long, for the whole composition is more important than the individual parts.

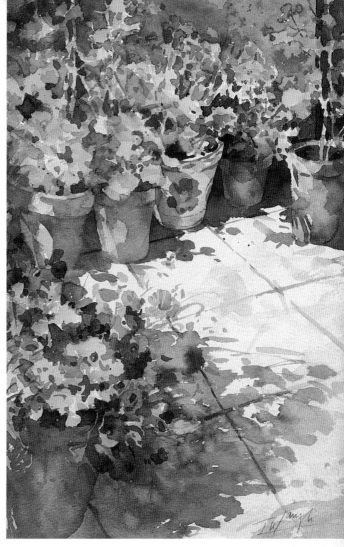

▶ **Patio Pots**
35.5 x 25.5 cm (14 x 10 in)

This painting shows the effect of sunlight on flowers in pots. Note that no individual flower is more clearly seen than any other; in this picture it is the blue patterned pot that is the odd man out and therefore acts as the focal point.

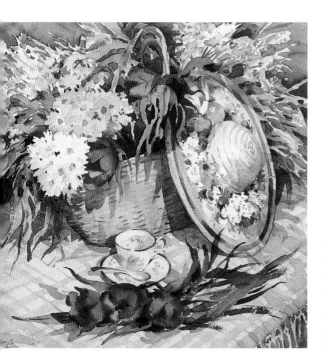

◀ **Flower Basket**
32 x 32 cm (12½ x 12½ in)

The chaotic arrangement of flowers in the basket overlaps the straw hat and is in turn overlapped by the foreground flowers and teacup. This makes a circular rhythm through the painting and ties the background and foreground together.

Backgrounds

Try not to think of your painting as containing two disparate parts – subject and background. If you think about your painting as a whole it is easier to achieve harmony. I sometimes finish a flower painting with broad washes of transparent colour glazed over subject and background to pull the whole painting together. Paint some parts of the background as you go along, as it can help to describe the petal of a flower if you paint the negative spaces.

All too often I have noticed that flower paintings have drab, or grey, backgrounds; I like mine to be full of colour, even in darker areas. The use of large washes can really help here, and floating in colours wet-into-wet behind flowers can be a real joy. When you are painting a large wash in a background area, keep it moving and flowing. As you progress with the brush you will find that you can paint around even the most complex floral shape confidently.

Remember that not every leaf has to be painted; I like to play 'now you see me, now you don't' with foliage, with some leaves articulated and others merely suggested, a technique which can be referred to as 'lost and found'. Most flowers seen in sunlight turn their heads towards the sun and consequently there are cast shadows behind them; remember to take these shadows into account when painting the background foliage. There should always be a visible passage from foreground to background, and such shadows can be a means of providing it.

Although it is important to pay attention to all these things when you are painting flowers, try to approach the subject with a carefree attitude; I think that this will make your florals fun to look at and certainly enjoyable to paint.

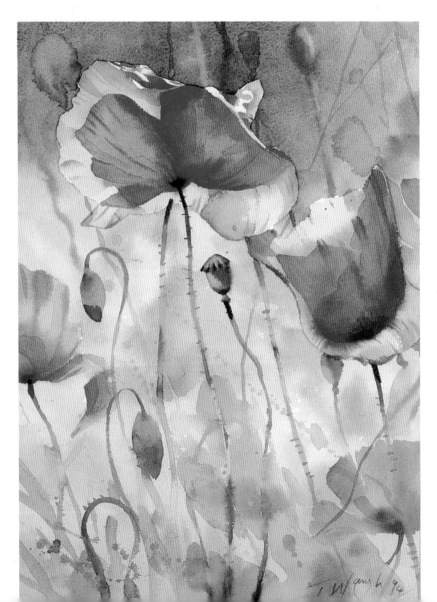

◀ **Three Red Poppies**
35.5 x 25.5 cm (14 x 10 in)

There is a lavish use here of complementary colours between background and subject. The two main poppies were painted first and allowed to dry, then the background was done in one hit with a large wash, dropping in the colours wet-into-wet. Note the low viewpoint taken of the poppies.

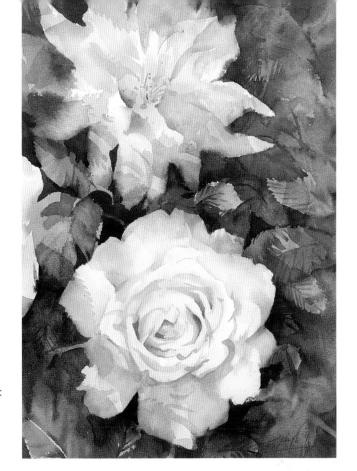

▶ Roses for Michèle
48.5 x 32 cm (19 x 12½ in)

Normally two large flowers compete with one another, but in this case I have made use of the variety of their shapes to give them different identities. I have also used a touch more red in the lower bloom to draw the viewer's eye. In this painting I have deliberately kept the background neutral, which focuses the viewer's attention on the blooms.

▼ Crossing Cottage Poppies
29 x 48.5 cm (11½ x 19 in)

The background in this painting was done in three washes: a large pale wash initially, then some of the spiky leaves and, to finish off, a large dark wash. I even tried some splashing on the right-hand side to add a bit of texture. All this creates interest and texture in the painting.

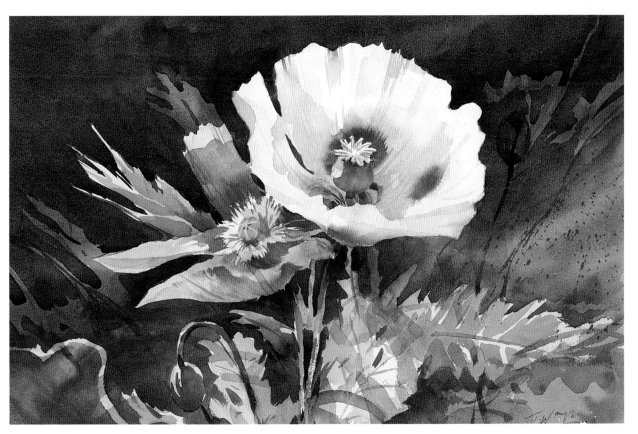

Demonstration White Roses

Painting a floral study

MATERIALS

Brushes Round brushes No. 14 sable, No. 8 Diana Kolinsky sable, No. 5 sable

Colours Aureolin, Cadmium Orange, Cadmium Red, Cobalt Green, Coeruleum, French Ultramarine, Naples Yellow, Permanent Violet, Rose Madder Genuine

Paper Whatman 400 gsm (200 lb) Rough

Other items Daler-Rowney Educational Stacking Palette BB9; lightweight board; 5 cm (2 in) brown paper masking tape; 2 large water jars

▲ **STAGE 1**
I began with a variegated wash, using all the colours on my palette and applying them with my large brush to cover the entire surface of the paper, starting at the top left and working to the bottom right. I added each colour separately, allowing them to merge on the paper. After the sheen of water had settled back on the painting I dried it with a hair dryer.

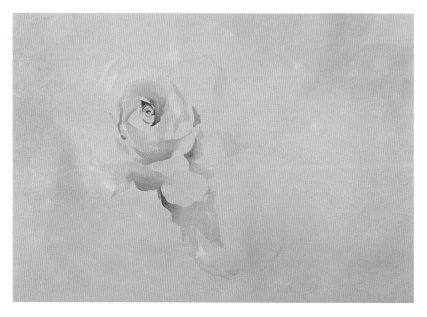

◀ **STAGE 2**
With my No. 8 brush I used Cadmium Red, Cadmium Orange and Rose Madder Genuine to make a start on the centre of my focal point rose. While the paint was still wet, I dropped in some dark colour mixed from Cadmium Red with a touch of Aureolin to create the centre and curl of the rose, using the tip of the brush. I employed cooler colours – Cadmium Orange and Aureolin – as I painted the petals further towards the outside of the rose.

▶ STAGE 3

I blocked in the second rose with the same colours then added more definition to the focal point rose. With French Ultramarine and Rose Madder Genuine I painted the shadow area on the left of the rose, then dropped in Cadmium Orange and Aureolin to form a green. I strengthened the shadow area with Cadmium Orange then started to put in some of the background foliage, flooding in soft dark colours wet-into-wet from the edge of the flowers and moving outwards.

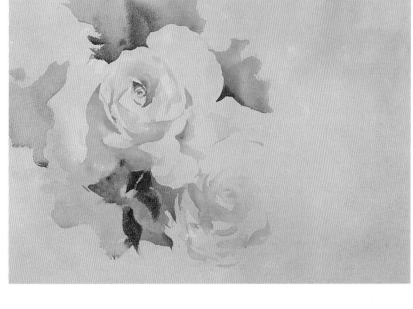

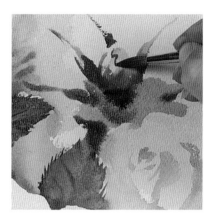

◀ STAGE 4

With Cadmium Red and a little touch of Naples Yellow I put in another rose to the right of the picture. I then added a bud of another rose behind that, drawing a dark red with the tip of the brush to produce the edge of the tightly curled petal.

▶ STAGE 5

Using wet-into-wet technique, I painted the background foliage using Coeruleum and Aureolin. I covered the entire background area with one large wash, remembering to keep the bead of liquid moving.

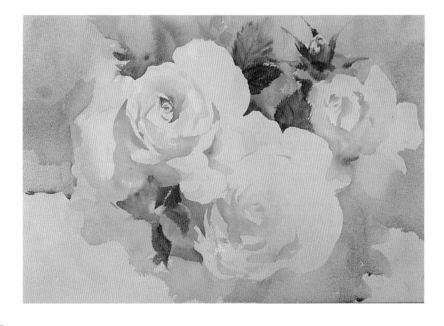

▶ STAGE 6

When I toned down all the light areas of the background to an intermediate tone by using large washes of Aureolin, Coeruleum and French Ultramarine allowed to mix on the paper, the effect produced a heightened sense of light on the roses. This helped them to stand out in relief and everything else in the painting became subservient to them.

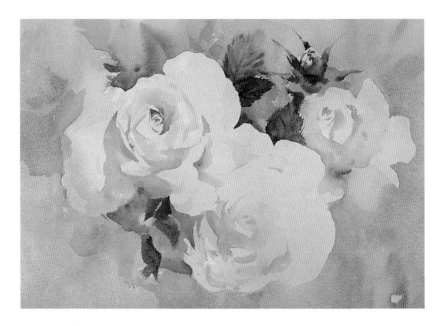

▶ STAGE 7

I painted in the stem of the rose with a muddy mix of colours, the 'sweepings of the palette', pulling the brush and varying the pressure to create a thick and thin line with a single stroke of the No. 8 brush.

◀ STAGE 8

Next I painted in the occasional thorn, using the body of the brush and pressing slightly to achieve the shape. The thorn tip was easy to put in at the end of a stroke as I lifted the brush away from the painting. I put in a few dark accents in the background to help the roses to stand out and also to add variety of shape.

◀ STAGE 9

Next I concentrated on the tones and shadows. The petals in the lower rose became more apparent when the warm tones were strengthened, using combinations of Cadmium Red and Cadmium Orange. In order to soften some edges of the petals I used my large brush dampened with clean water.

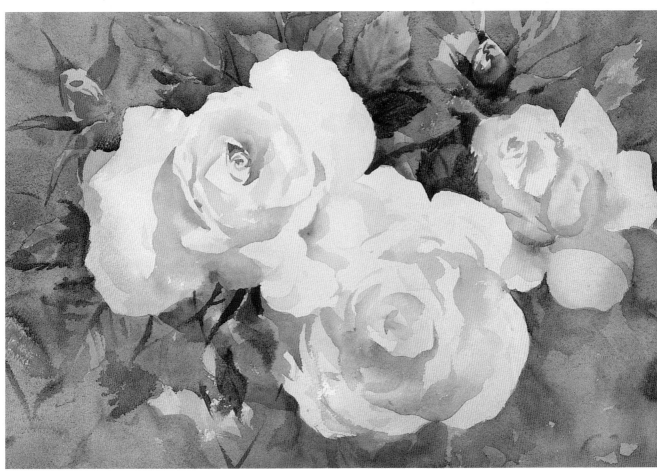

Roses in Bloom *34.5 x 51 cm (13½ x 20 in)*

▲ STAGE 10

I put in the dark background areas with French Ultramarine and Alizarin Green, applied separately wet-into-wet and glazed over the wash beneath, which by now was dry. A large wash of French Ultramarine helped the background to recede.

Next I dropped in a little purple at the top right of the picture in order to create balance. The final step was to use a little Rose Madder Genuine mixed with the purple on the paper to give the suggestion of another rose disappearing in the bottom right-hand corner.

WINNING TIPS

Painting flowers

- Paint flowers from the centre out.

- Pick out one or two flowers as a focal point.

- Use 'lost and found' technique with foliage.

- Consider the harmony of the whole painting.

- Paint the background as you go along.

- Use large washes and transparent glazes to pull your painting together.

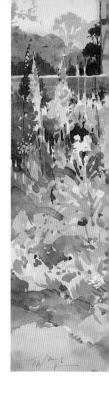

▶ **Flower Border**
32 x 32 cm (12½ x 12½ in)

When painting this garden in Berkshire I made use of the negative spaces between the columns and the delphiniums to help create a sense of depth. Splashes of opaque white were used to create some of the smaller flowers. I tried to keep each flower as a simple blob of paint.

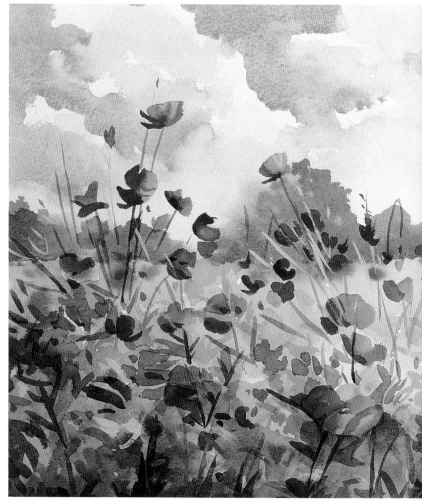

▶ **Poppy Field**
25.5 x 35.5 cm (10 x 14 in)

I painted this from background to foreground, placing the poppies and grasses last of all. When choosing a subject like this I always like the flowers to break the skyline as it creates vertical movement in an otherwise horizontal composition.

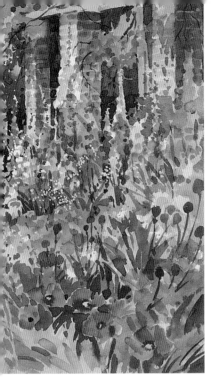

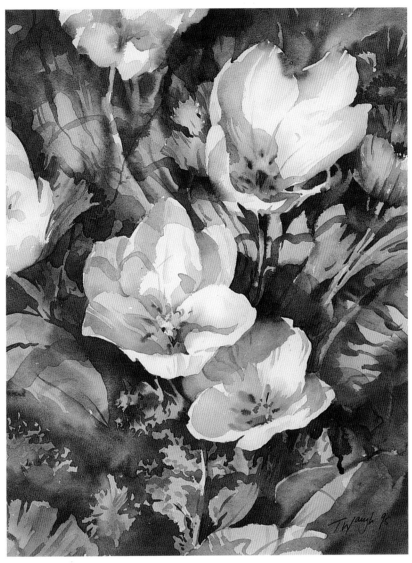

▲ **Tulips**
61 x 51 cm (24 x 20 in)

Here I tried to describe the movement as the tulips sought the
sun. This was a complex background and I had fun using
plenty of colours and playing 'lost and found' with the foliage.
Note the cast shadow on the bottom tulip and how it also
invades the foliage.

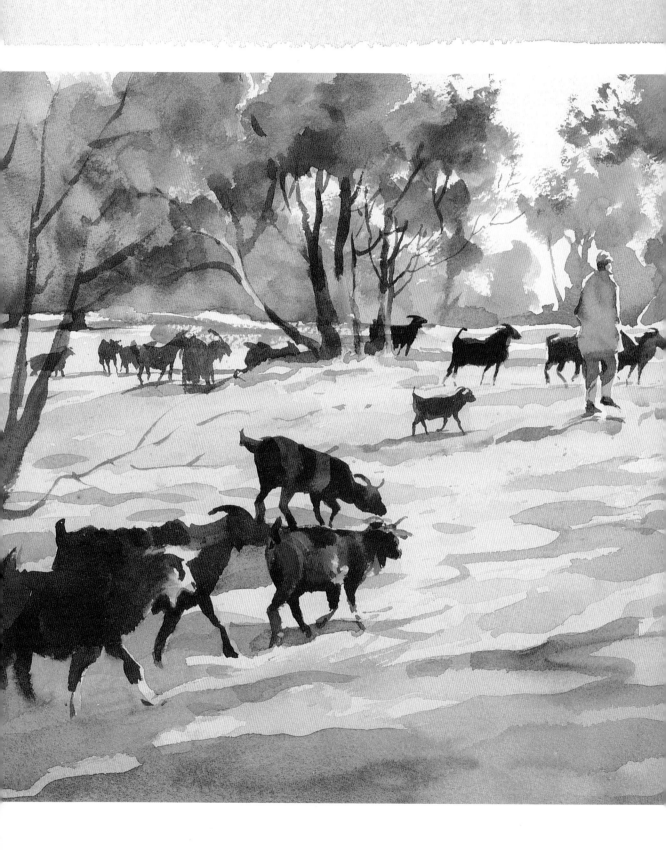

Animals in a Setting

When it comes to painting animals my preference is for domestic breeds, and animals in groups or herds rather than individual pet portraits. Old farmyards or country cottages with a few chickens or ducks outside a doorway are favourites of mine. This gives me a chance to paint an attractive scene, with animals adding a sense of life and charm to the place. I keep ducks and chickens in my own garden, which provides me with the opportunity to observe them in greater detail. I spend a lot of time in preliminary sketching and study before painting animals as I like to familiarize myself with their form and behaviour and to make sure that I have the proportions and coloration correct.

Getting the details right

Details such as beaks, noses, tails, eyes, legs and ears need to be accurate and special observation of these is imperative. I take photographs to use for reference, making a complete tour of the animals with my camera and taking snaps of them from every conceivable angle. Most importantly, I make detailed notes and studies in my sketchbook, sketching an animal again and again to get it right, including its setting.

◀ **The Goatherd**
29 x 48.5 cm (11½ x 19 in)

I came upon this wonderful sun-filled scene of a goatherd tending his goats as I was driving through the Atlas Mountains in Morocco. I painted the picture later in my studio, using an initial watercolour sketch from my journal, and concentrating on the placing of the groups of goats and the sequences of light and shadow.

Construction

When you are drawing an animal it is necessary to study the basic shapes of its form, as without a thorough understanding of these shapes your drawings and subsequent paintings will not ring true. Observe a cow or a goat: its basic body shape is box-like and the head and legs are in particular proportion to this shape. If you make them too big or too small the animal will look unbalanced and unnatural. In the case of ducks and geese, the head and body shapes are oval, or egg-like, with beaks, tails and feet triangular in nature. Portraying these basic shapes accurately in your drawings and paintings will bring a three-dimensional quality to your animals. How these shapes fit together with the details and coloration should be of primary concern in your construction studies.

Knowing the form

Studying basic shapes will lead you to an understanding of form and once you are thoroughly familiar with the form of an animal it is possible to draw or paint it almost from memory. A simple way to practise getting the form right is to paint animals in silhouette, which allows you to concentrate on the overall shape without becoming confused by details.

Observe shadow areas and undulations in an animal's form and when you are painting it in

▲ ▼ These two simple construction drawings show the basic box shape of a goat and the animal in a slightly more developed form.

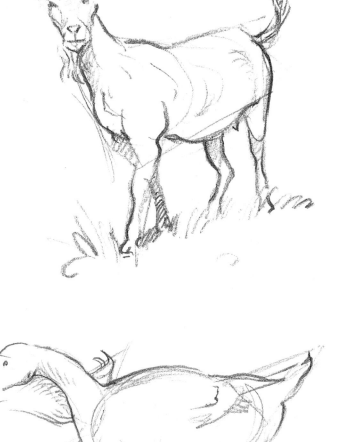

▶ I spend a lot of time getting to know the form of an animal. Here I've concentrated on the forms of two ducks and how they relate to each other, drawing them with pencil.

watercolour make special reference to these. Cast shadows and reflected light and colour all play a part in creating form. For instance, when the sun shines on a duck it may cast shadows under the beak and over the contour of the body, and you can use these shadows in your painting to give the illusion of form. Other objects in the setting may also throw shadows and this will help with placing an animal in its surroundings so that it looks natural.

▶ In this line and wash sketch of a cow I was interested in how foreshortening affected the overall form.

▲ ▶ The drawing of the duck gives an indication of movement by means of the placement of his feet and shoulders. The activity produced by a handful of corn tossed to the cockerel and hens created an opportunity to do a quick sketch.

Movement

Describing movement can be somewhat tricky. I often make what I call 'action drawings' using a continuous pencil line, starting at the point of action and then working away from it; for example, in the case of chickens feeding I might start with their beaks and then plot the action of their bodies. In the case of a group of horses racing it sometimes looks almost as if their legs are tangled together, so careful observation is needed in order to capture that impression. Remember that there is more movement in groups and herds, so how one animal overlaps and interlocks with another is important. Not only does the arrangement of their bodies indicate their behaviour, it also forms patterns in a painting.

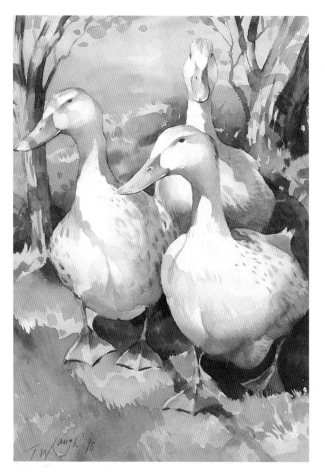

Proportion and foreshortening

Just as form and movement will create a sense of reality in your paintings of animals, proportion and foreshortening also have to be right if you are to obtain a convincingly three-dimensional look. The size of the head in relation to the body is critical in the majority of animal paintings and should be one of the first reference points in getting the proportion correct. Check your measurements here constantly, because there is a tendency for artists to make animals' heads too large. The scale of the animal to its surroundings is also significant; keep asking yourself if you have the scale correct and if not redraw until it looks right.

Foreshortening occurs when an animal is coming towards or going away from the viewer. Some parts are lost from view, but you still need to be aware of them and how they fit together with the parts that are seen. Foreshortening can create a fantastic sense of reality and your animals will seem almost to pop out of the painting if you can capture this.

▲ **Silver Appleyards**
35.5 x 25.5 cm (14 x 10 in)

All three ducks in this painting are seen foreshortened and the difference in proportion of one to another is slight but noticeable. The cast shadows are helpful in describing form and contour.

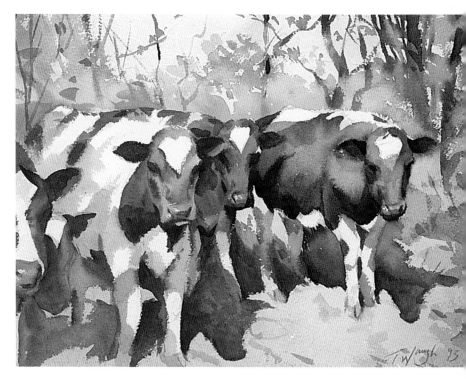

▶ **Young Friesians**
25.5 x 35.5 cm (10 x 14 in)

This painting shows a group of cows huddled together, the black and white shapes of their markings intermingling. The frontal aspect shows their forms with maximum foreshortening.

▶ We Three Geese
25.5 x 35.5 cm (10 x 14 in)

All three geese overlap one another and although they are all travelling in the same direction the middle goose, looking at the viewer, is the odd man out and therefore the focal point. Because of the complexity of the negative spaces the broken fencing was more difficult to paint than it might seem.

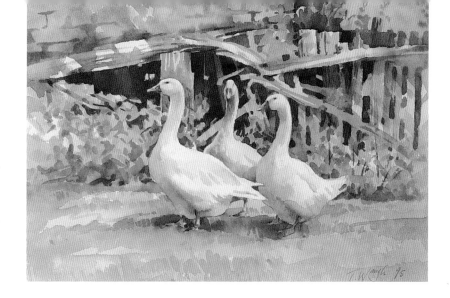

Concentrating on the negative spaces around and between the animals in a group, together with using counterchange techniques and asking yourself simple questions such as 'Is the animal darker or lighter than the background?' or 'Are the animals in the foreground or background of the painting?' is also helpful.

▼ Cows in the Snow
33 x 48.5 cm (13 x 19 in)

Pale washes of colour were applied over the whole paper to create the snow, then the dark patterns of the cows were painted on top. I moved the cows slightly from their natural formation to make a pleasing composition.

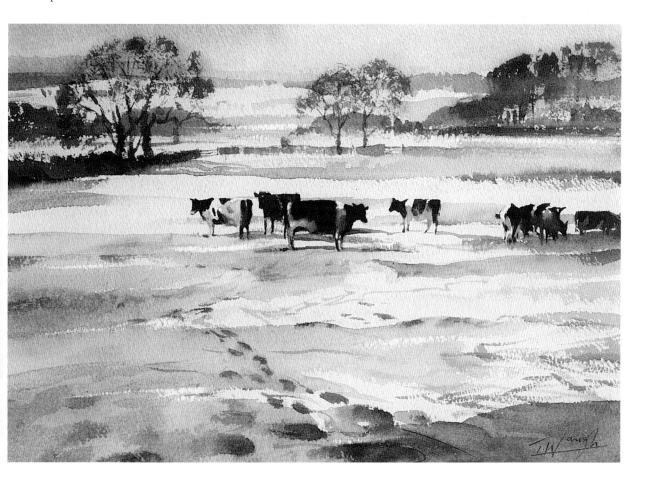

Demonstration Moroccan Donkeys

Painting animals in a landscape

MATERIALS

Brushes Round brushes No. 14
sable, No. 8 Diana Kolinsky sable,
No. 6 sable

Colours Aureolin, Burnt Sienna,
Cadmium Orange, Cobalt Blue,
Cobalt Violet, Coeruleum, French
Ultramarine, Naples Yellow, Raw
Sienna, Rose Madder Genuine,
Yellow Ochre

Paper Whatman 400 gsm
(200 lb) Rough

Other items Daler-Rowney
Educational Stacking Palette BB9;
lightweight board; 5 cm (2 in)
brown paper masking tape;
2 large water jars

▲ **STAGE 1**

I started by laying down a
variegated wash with a large
brush, using Cobalt Blue and
Coeruleum painted wet-into-wet
from top left to bottom right. I
then added in Naples Yellow,
Coeruleum and Aureolin for the
greens, allowing the colours to
mix on the paper. Just a touch of
Cadmium Orange dropped into
the foreground of the painting
created a feeling of warmth and
gave a sense of recession right
from the beginning.

◀ **STAGE 2**

Using a No. 6 brush which comes
to a good point, I blocked in
some of the general shape of the
donkey's head and shoulders. I put
in some of the dark recessed areas
straight away. After dropping in
the eye wet-into-wet, I painted his
nose using negative painting.

STAGE 3

I used Aureolin and a bit of Cadmium Orange to paint the blanket over the saddle. A little Yellow Ochre added in here and there warmed it up. Then I concentrated on some of the details in the face, trying to get the shapes correct.

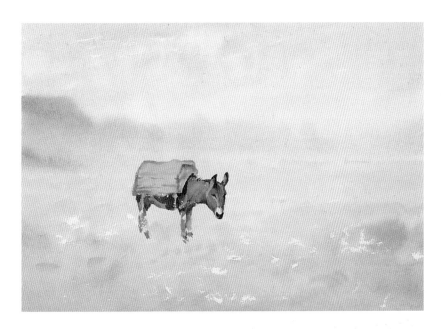

STAGE 4

After painting a few details on the donkey such as the stripes on the blanket, I blocked in the shape of the second one. I used a bit more French Ultramarine in the mix to give it a darker coat, making the first donkey appear to come forward in the picture. As I worked around the edge of the first donkey I took care not to destroy the shape. I used Naples Yellow for the paler areas on both donkeys and painted the red and blue blanket with Rose Madder Genuine and French Ultramarine.

STAGE 5

After adding a few more details to the red and blue blanket I put in the grasses obscuring the donkeys' feet, using Yellow Ochre and Coeruleum in a half-and-half mix to give a feeling of sand. I articulated the stones by pulling in the wash behind them and dropping in some Burnt Sienna on their edges. The next step was to use the pull technique to paint in the blades of grass, this time with more Coeruleum than Yellow Ochre in the mix to make it darker.

STAGE 6

With my No. 8 brush I painted in some Cadmium Orange and Cobalt Violet to show the rocky terrain. I put down a large wash, leaving out crevices for foreground stones. I dropped in a little Raw Sienna here and there; it looks grainy when it dries, so it was useful for this sandy environment. French Ultramarine and Aureolin mixed together produce a dark green, which I used for some of the grasses on the right-hand side of the picture.

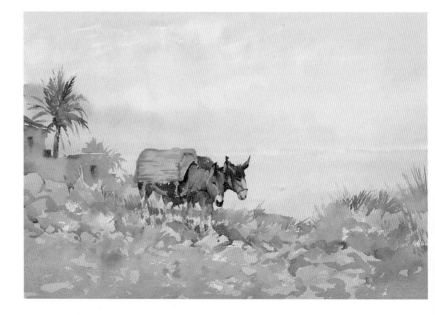

STAGE 7

I put in a small building on the left, using Yellow Ochre applied with a No. 6 brush, then dropped in dark tones made from a mix of French Ultramarine and Burnt Sienna to indicate windows. I brushed in some palm trees using Coeruleum and Yellow Ochre for the green that I wanted, painting the broad shape of the leaf with the whole brush; then, with the tip of the brush and a slightly darker concentration of the colour, I put in the palm fronds. The palm tree was softly brushed in so that it recedes behind the more defined shape of the building.

STAGE 8

With my large brush, I put in the shadows on the rocks with a mix of Rose Madder Genuine and French Ultramarine. I used Cadmium Orange for the foreground, varying between a loose wash and a dry brush to emphasize the texture. I splashed some greens in by gently tapping the brush, which creates a sense of spontaneity as well as adding to the texture.

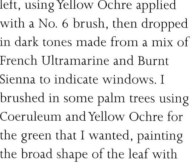

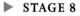

▲ STAGE 9

To emphasize the impression of
sand I brushed Raw Sienna across
the middle ground, including the
palm tree. I then applied a pale
wash of Cobalt Blue across the
horizon. Finally, I strengthened
the mountain areas with a wash
of French Ultramarine blushed
with Rose Madder Genuine.

Moroccan Donkeys *35 x 50 cm (13³/₄ x 19³/₄ in)*

Painting animals

- Decide if the animal is lighter or darker than the background.

- Look for the negative spaces around each animal.

- Keep a sketchbook to record details such as eyes, feet, tails and beaks.

- Remember that animals in groups tend to overlap one another.

- Study animals and their movements – observation is the key to success.

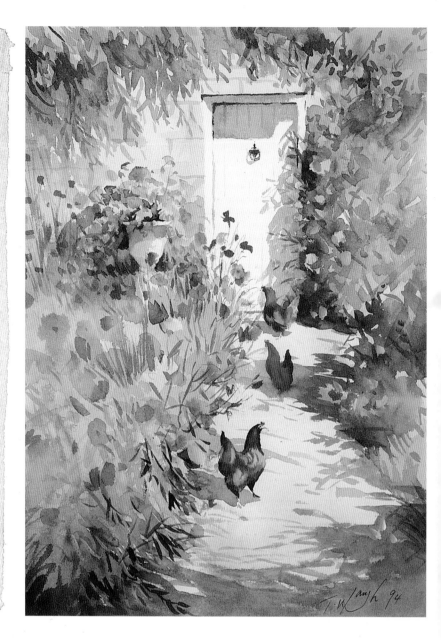

▲ **Mrs McGregor's Garden**
35.5 x 25.5 cm (14 x 10 in)

I really enjoy capturing sunlight on white surfaces, such as the front door and the path leading to it, and putting in the chickens with a few simple brushstrokes gave a touch of life and additional interest.

▶ **Cows in the Meadow**
25 x 33 cm (9¾ x 13 in)

The cow in the foreground has her back leg raised, creating a sense of movement that is reinforced by the overlapping shapes of the animals. The black patches in their coats contain hints of purple and blue.

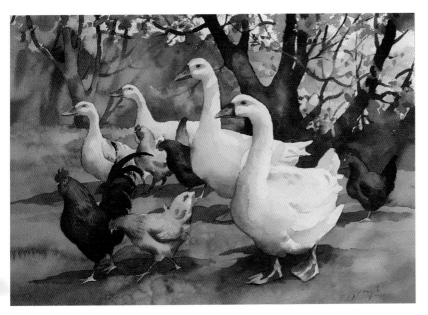

◄ **Our Gang**
34.5 x 49.5 cm (13½ x 19½ in)

I make good use of the ducks, chickens and geese in my back garden as models, studying their forms, movements and antics. This painting is about them as individuals and also as a group. The soft browns and greens are so evocative of the farmyard, and the contrasting tonal values, the coloration in the feathers and the setting combine to produce a harmonious picture.

From Mud to Masterpiece

Over many years of painting and teaching watercolour the most common complaint I have heard from professionals and beginners alike is 'My painting has gone muddy.' The most valuable advice I can give is that before you do anything you should let it dry, then assess the situation – a painting will often look better dry than wet. If not, the question arises, 'Can I make it win, or is it in the bin?' These potential failures can be your best friends, because you learn more about watercolour technique in difficult situations than when all goes well.

Making the best of it

Your best plan is to turn your imminent failures into opportunities; try to keep a positive outlook and an open mind. There are certain resurrection techniques that may help you, but there are also paintings that benefit from some muddy colours to contrast with the purer ones. A fresh eye can be helpful, so take a break and think about what to do; rushing at this stage could be disastrous for your painting. Check your water jars and palettes, for if there is mud on the palette it will inevitably find its way onto your picture. Above all, don't panic – just prepare yourself with clean equipment to tackle the situation afresh.

◀ **The Friday Pot Market**
33 x 48.5 cm (13 x 19 in)

In this painting, done near Dubai, the earthy colours such as Raw Sienna, Naples Yellow and Burnt Sienna all combine to evoke the location. The pale bluish-greys in the foreground shadows were made from Coeruleum and Naples Yellow. This is an example of muddy, or subdued, colours used successfully with brighter ones.

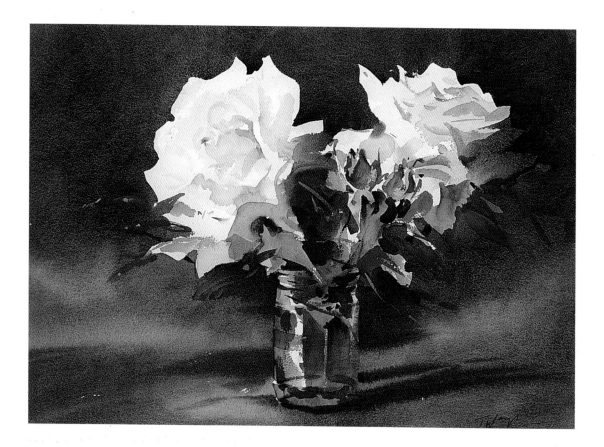

Darkening the background

Sometimes the colours in the background of a painting that is not working well are not so much muddy as washed out or patchy. Taking the decision to darken them a tone can bring a sense of continuity to those background areas as well as throwing the lighter areas into relief. A large brush and a darker dilution of your chosen colour, using plenty of water and plenty of pigment, should produce a darker and clearer wash. Remember to mix up more than enough to cover the required area in one go.

Many painters, especially in the past, have used dark backgrounds to create a sense of drama in their work. When I had the courage to attempt this for the first time I was very pleased with the result and surprised to find that watercolour could go darker than I thought. This is where your practice with large washes will really pay off, as you need to paint the entire area in one wash, painting around the subject matter. As you become more experienced

▲ **Roses in a Jar**
33 x 48.5 cm (13 x 19 in)

After painting the background with a half-tone wash of Cadmium Orange, French Ultramarine and Yellow Ochre I noticed that they had dried patchily. Also, there was not enough contrast with the roses. I made the decision to apply a dark, graded wash from a mix of Burnt Umber and French Ultramarine. At the end I added a few stabs of Cobalt Blue, straight from the tube, and I was happy.

you will find that you can choose to use either a large flat wash or a graded wash to create this effect.

Glazing

Glazing is particularly useful for creating not only continuity but also transparency. In this technique, watercolours are allowed to dry thoroughly and are then given a glaze of a transparent colour, or colours, which leave the colours beneath still visible (see page 21). This can transform an apparently unsuccessful painting at the finished stage. For

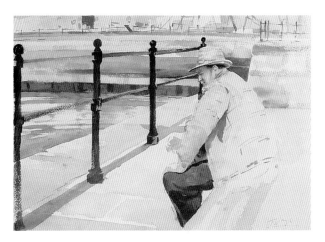

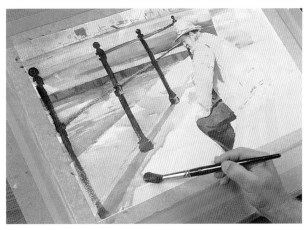

▲ On returning to my studio I took a fresh look at this painting that I had done in the harbour at Plymouth's Barbican area and decided that it was far too pale and needed correcting.

▲ Using a large brush and a large wash mixed from French Ultramarine and Rose Madder Genuine, I painted in some shadows, starting underneath the railings that lined the quayside.

successful glazing a light touch with a soft-haired brush, such as a squirrel or sable, is the most effective. If you press too hard with the brush you will find that it will lift or disturb the colours underneath. Keep plenty of water and plenty of pigment in your dilution; you cannot glaze effectively with pasty washes.

For this technique I have found certain colours more effective than others. For example, transparent purples and blues can create subtle shadows when dry; the madder colours are handy for transparency and warmth; and Aureolin and Indian Yellow are very good for making vibrant greens in an area of foliage that has lost its lustre.

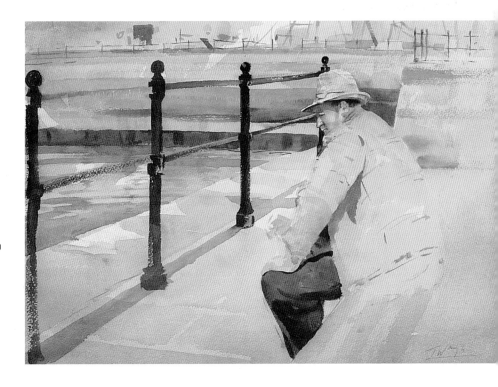

▶ **Sitting by the Harbour**
30.5 x 48.5 cm (12 x 19 in)

Continuing with my large brush, I glazed shadows all across the picture with the same two colours, altering their proportion in the mix to vary the temperature of the shadows. This has given the painting much more depth and vitality, and because of the extra contrast the viewer is more aware of the strong light.

Covering up mistakes

Gouache (also known as body colour) is an opaque type of watercolour paint which is compatible with transparent watercolour. In fact, areas of opacity in a watercolour sometimes succeed in highlighting the more transparent areas by contrast. They can be laid on thinly to provide a base that can be reworked when dry.

When covering up a mistake in a painting, apply your body colour evenly; mix up your dilution to the consistency of single cream for the best results. Again I must stress that pasty colours or a heavy hand will only make more problems than they

solve. I find that the most useful way of using opaque white is to tint it with whichever colour is appropriate to the area in which it is to be applied, rather than using it pure white; this has a softer look and is less noticeable in the finished piece. Used correctly and deliberately, body colour can enhance a dreary or lifeless wash. A word of warning: there is nothing worse than muddy body colour, so take care.

Resurrection techniques

Resurrection techniques all require patience and a steady hand. For large muddy areas you will find that a razor blade can scratch out back to the paper, or, if used sideways like a brush, can produce texture and sparkle. A putty eraser can be used to lift off some colours, creating clouds in a blue sky, for example. It is a good idea to practise

▼ In this painting of a house and vineyard in the South of France I was unhappy with two aspects: the line that had appeared in the sky, caused by the rapid drying time in the heat, and the somewhat muddy colours in the foreground.

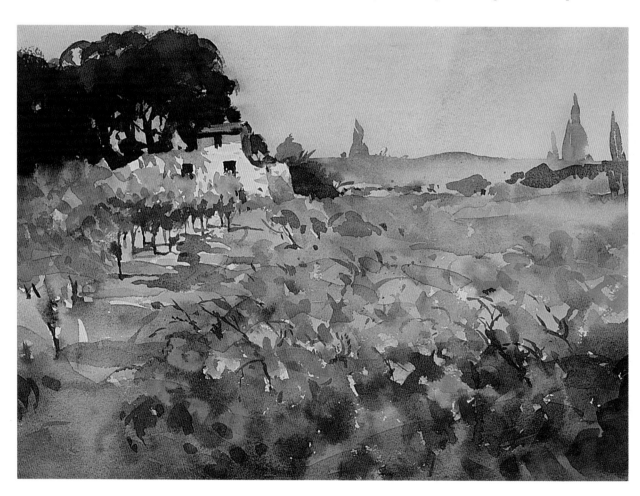

this and discover for yourself which colours can be erased and which colours resist this treatment. When you have erased certain areas it is also possible to paint over them again. Obviously you need to keep the putty eraser clean by constantly removing the paint from the eraser as it comes off the painting.

If you dampen an area with clean water it is possible to lift out colours with a soft brush, a paper towel or even a cotton bud. For more stubborn areas I have found a hog bristle brush invaluable. For example, you can create the white masts of boats by laying paper masks on either side of the mast area, dampening the painting in between with clean water and lifting out the masts with a hog bristle brush – a bit like reverse stencilling.

To practise these techniques, use failed paintings or old ones you no longer want.

Ultimately you may not be able to save your picture, but your skill will have developed and your knowledge of different techniques will have improved. You can certainly have a lot of fun trying them out.

▼ **The White House, Provence**
30.5 x 48.5 cm (12 x 19 in)

For the sky I mixed Cobalt Blue with Permanent White gouache and applied a graded wash, adding more water to the mix as it approached the horizon. For the foreground I used Permanent Mauve mixed with Permanent White gouache to paint in some bunches of grapes. I also created a bit more texture on the right-hand side by scraping away some of the original wash with a blade.

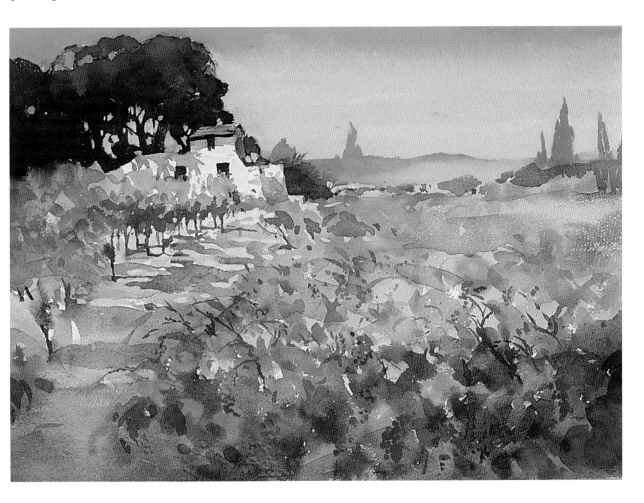

Index